PHOTOGRAPHS
MARK PERROTT
E BLOCK

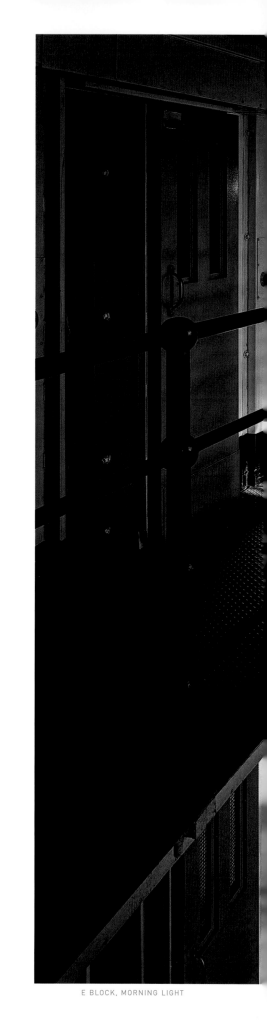

E BLOCK, MORNING LIGHT

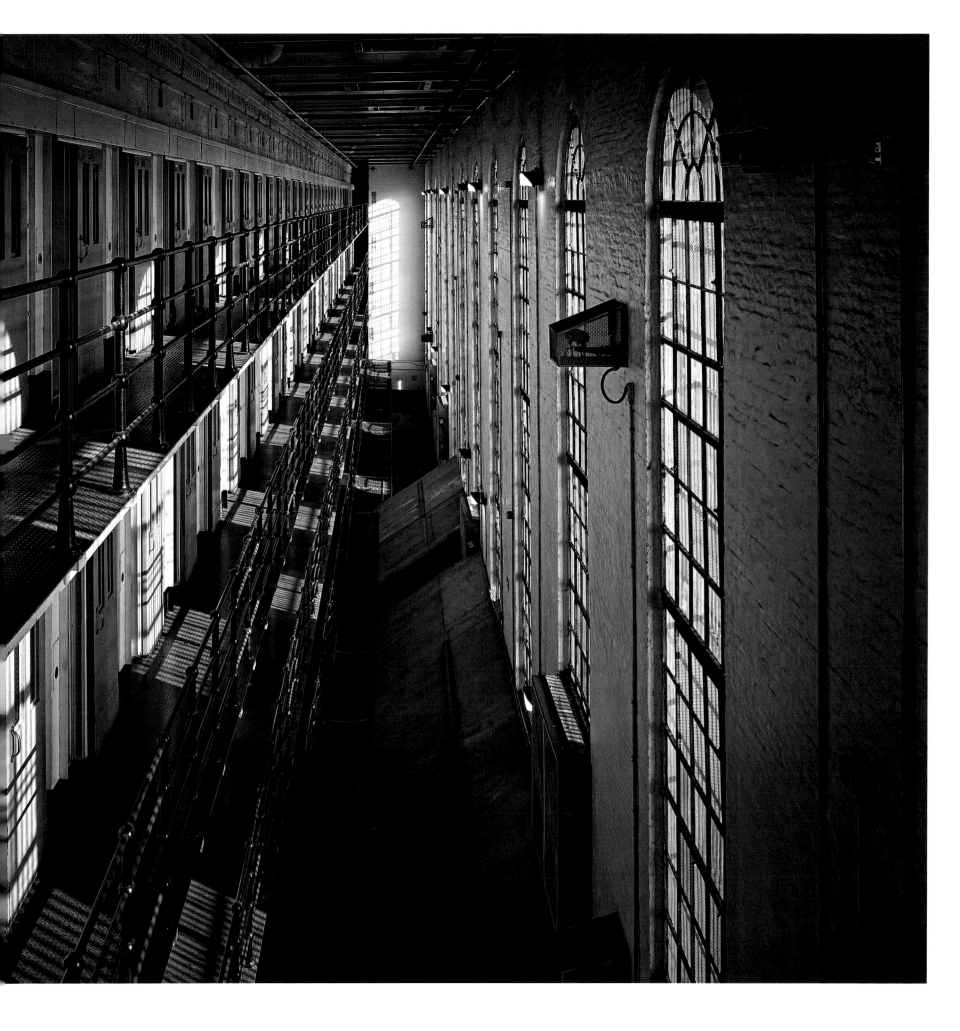

E BLOCK

Photographs: Mark Perrott
Introduction: Adam Gopnik
History: Pennsylvania Historical and Museum Commission
Design: Landesberg Design
Printing: Bolger, Minneapolis, Minnesota
Publisher: Woods Run Press LLC

Library of Congress Control Number 2013931494

ISBN 978-0-615-75802-2

First Printing
Printed in USA

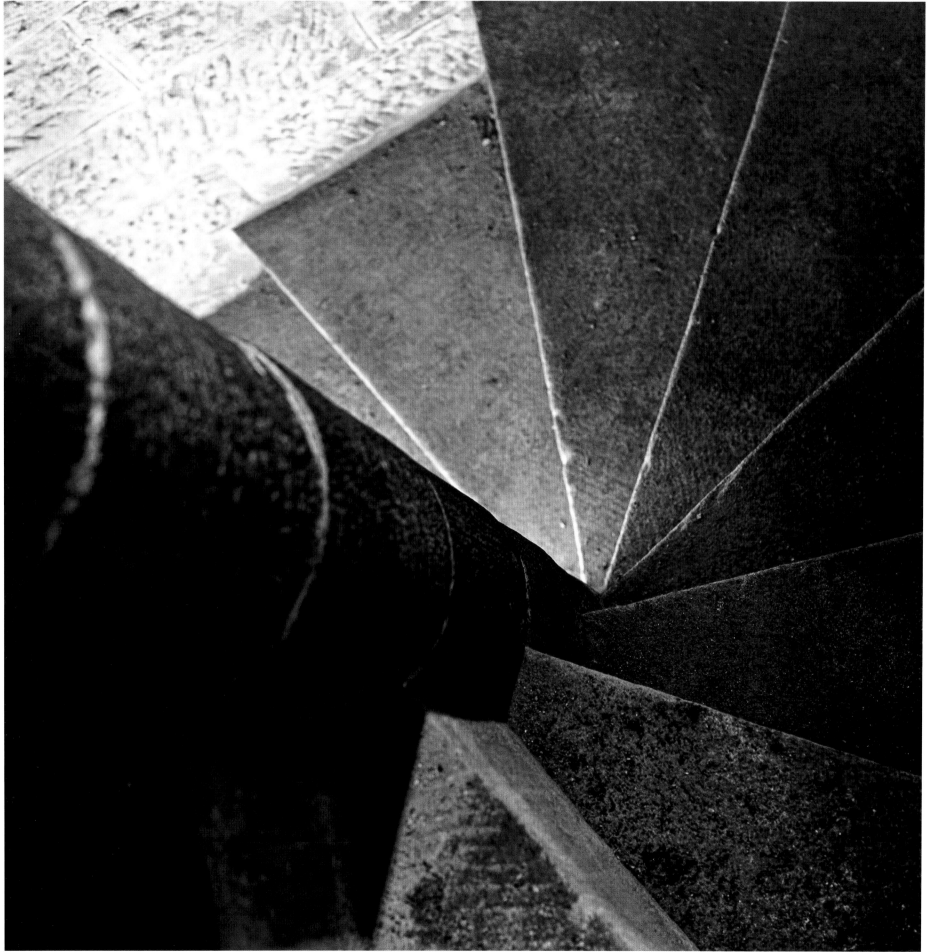

STAIRS TO GUARD TOWER

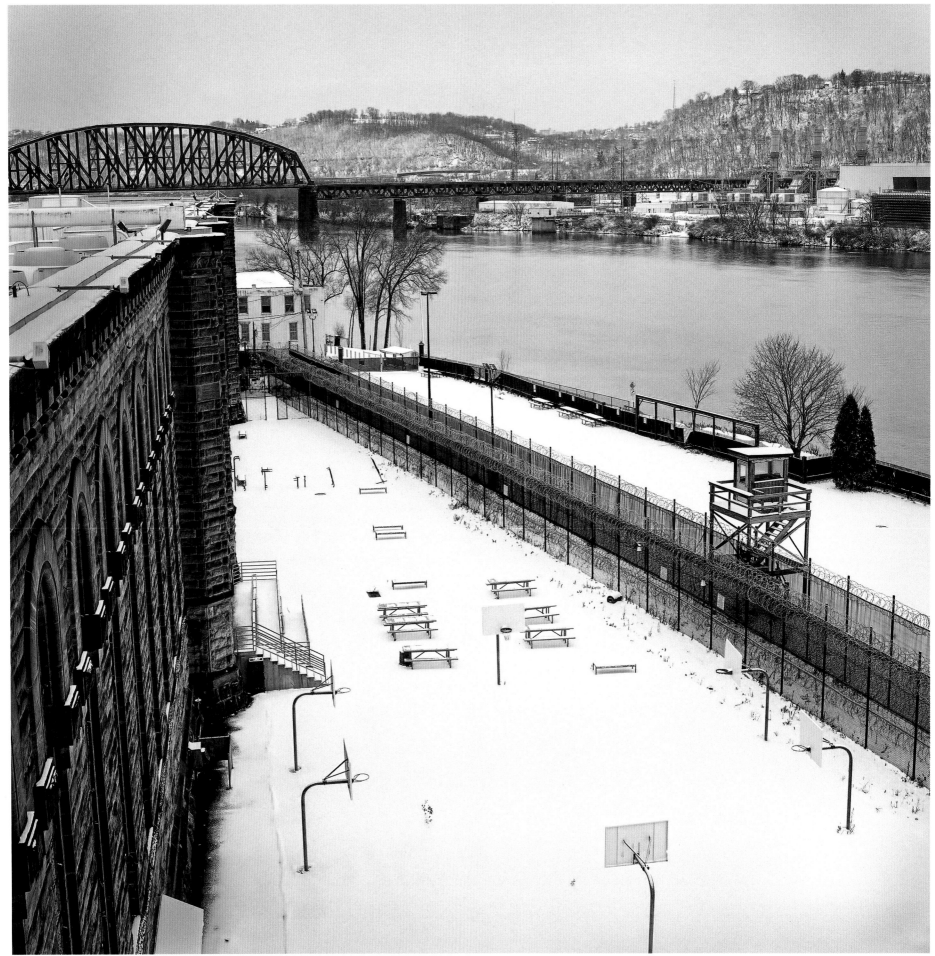

RIVERSIDE YARD, 2006

estern State Penitentiary opened on July 1, 1826, with the arrival of its first twelve inmates: eleven men and one woman. As additional commitments grew, new cells were added, but not enough to offset overcrowding problems. By the late 1870s cells designed for just one prisoner often held two, three, or even four inmates. In 1878, the Board of Inspectors chose a new site just west of Pittsburgh, Pennsylvania, to construct a larger and more modern institution.

Architect E. M. Butz's redesigned Western State Penitentiary was built between 1878 and 1892 at a cost of just under $2 million. Beginning in 1885, inmates were gradually moved to what was then the most modern and expensive prison in the world. Modeled after Auburn's congregate system, Pennsylvania's new Western Penitentiary had a capacity of 750 inmates, and it was the first prison with electric lights, running water, and a toilet in each cell. It also was the first prison to equip each of the cells with heat and exhaust ventilation, and was the first to use "gang locks," which enabled a guard to open and lock a row of cells with a single lever.

Western's modern technology, however, was not enough to overcome other problems. Frequent flooding of the nearby Ohio River was always a threat to the safety of inmates and employees. The worst flood occurred on St. Patrick's Day 1936, when the Ohio River crested at forty-six feet and submerged downtown Pittsburgh, and the entire Penitentiary site, under more than seven feet of water.

The Pennsylvania Department of Corrections had proposed closing Western Penitentiary many times before the last busload of inmates left on January 13, 2005, and headed north to a new prison in Marienville, Forest County. By then, Pennsylvania's oldest prison had become the most expensive prison, per inmate, to operate.

On July 1, 2007, nearly two years after closing, the Pennsylvania Department of Corrections reopened the facility to house Pennsylvania's growing prison population. It now functions as a minimum and lower-medium security facility for more than 1,500 inmates.

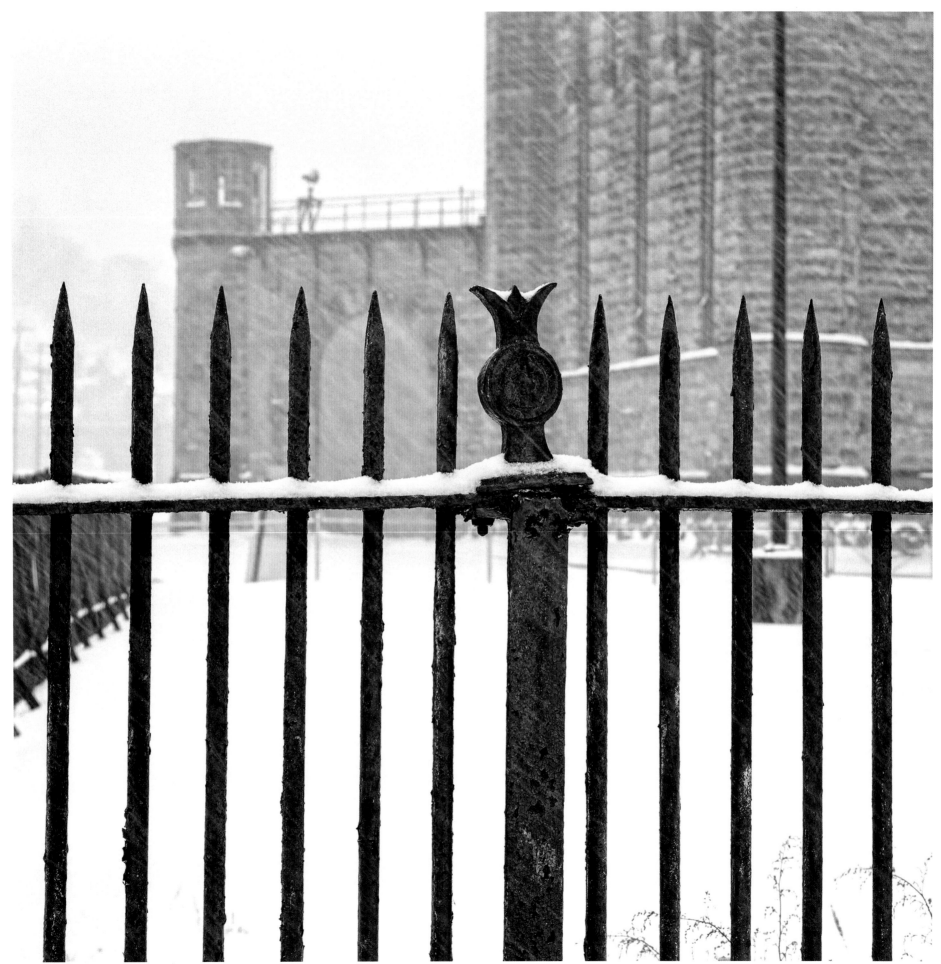

IRON FENCE, SPRING SNOW

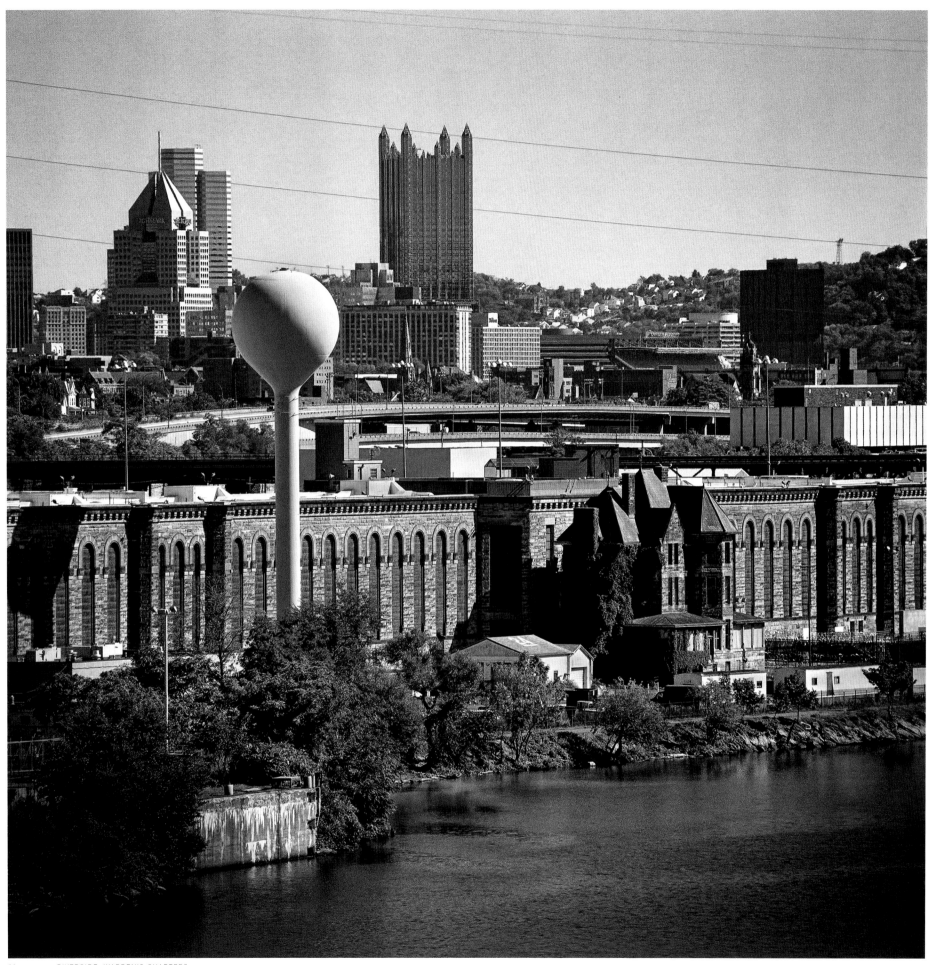

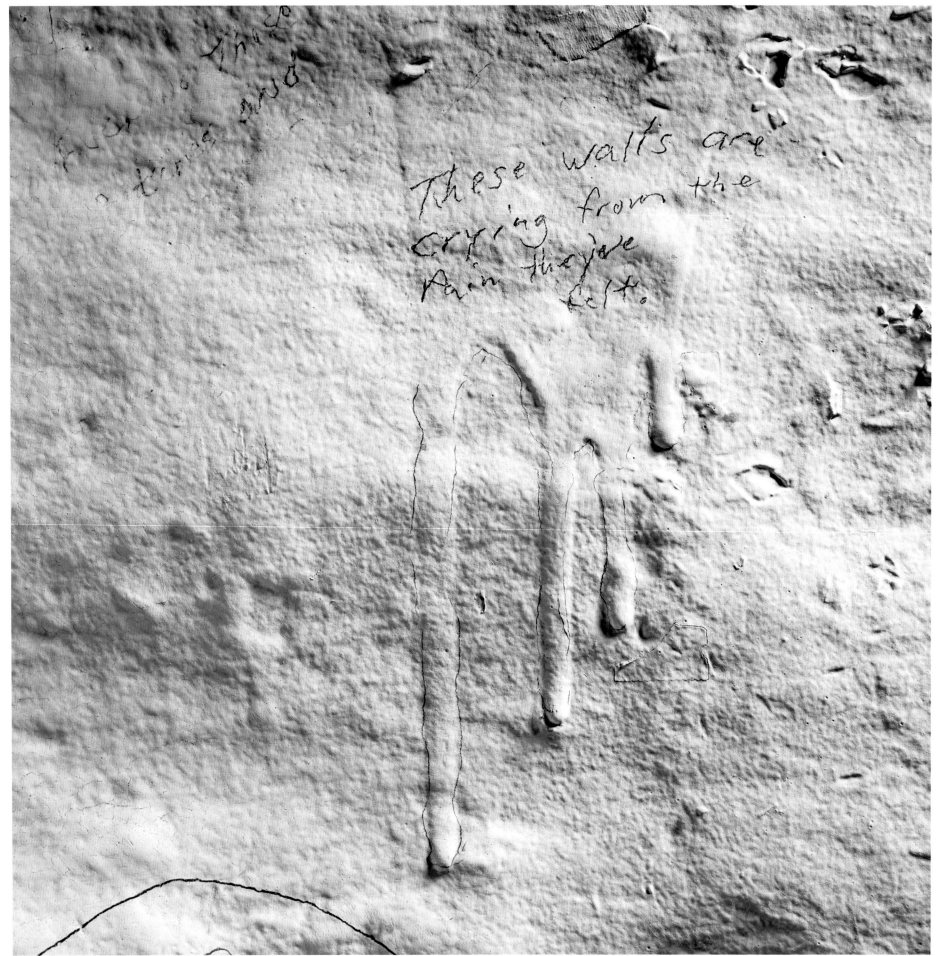

was certain I'd explored separation anxiety and survivor guilt sufficiently in my life during my visits to Philadelphia's Eastern State Penitentiary—so in 2005, when I read that Pittsburgh's Western Penitentiary, located just downriver from PNC Park and the Carnegie Science Center, was about to close, I didn't feel compelled to act. But later that same day, curiosity got the best of me, and I requested permission to take a day-long tour of this 1885 Gothic sandstone structure. I was lucky. I ended up walking the site with Bill Stickman, a former Pennsylvania Department of Corrections administrator, who had begun his career at Western Penitentiary 30 years earlier as a Corrections Officer. We walked through many spaces of confinement and institutional organization, like the Mess Hall, Laundry, Commissary, Shoe Shop, Chapel, and the dark, shed-like Correctional Industries buildings, where inmates made license plates in a gymnasium-sized room filled with blackened and grease-covered stamping presses.

But none of this prepared me for the experience of E Block. The Department of Corrections dedicated these ground-floor and second tier cells to the housing of prisoners sent for the first time to this state correctional institution, and for returning parole violators. Prisoners spent three days to two weeks here, until the system "classified" them and moved them along to other cellblocks or to other institutions. I entered the first cell—#135—five feet wide, eight feet deep, with a low metal bed, a sink, a toilet, and four whitewashed walls, covered almost entirely with graffiti. *I read every square inch of each wall.* These were the unfiltered voices of men in their first days of separation and incarceration. Their words were raw, accompanied sometimes by childlike drawings. As I moved from cell to cell, these voices became a chorus of shame, rage, bravado, advice, hate, humor, confession, and contrition. Over the next year, I wrote down each word and photographed every surface.

MARK PERROTT

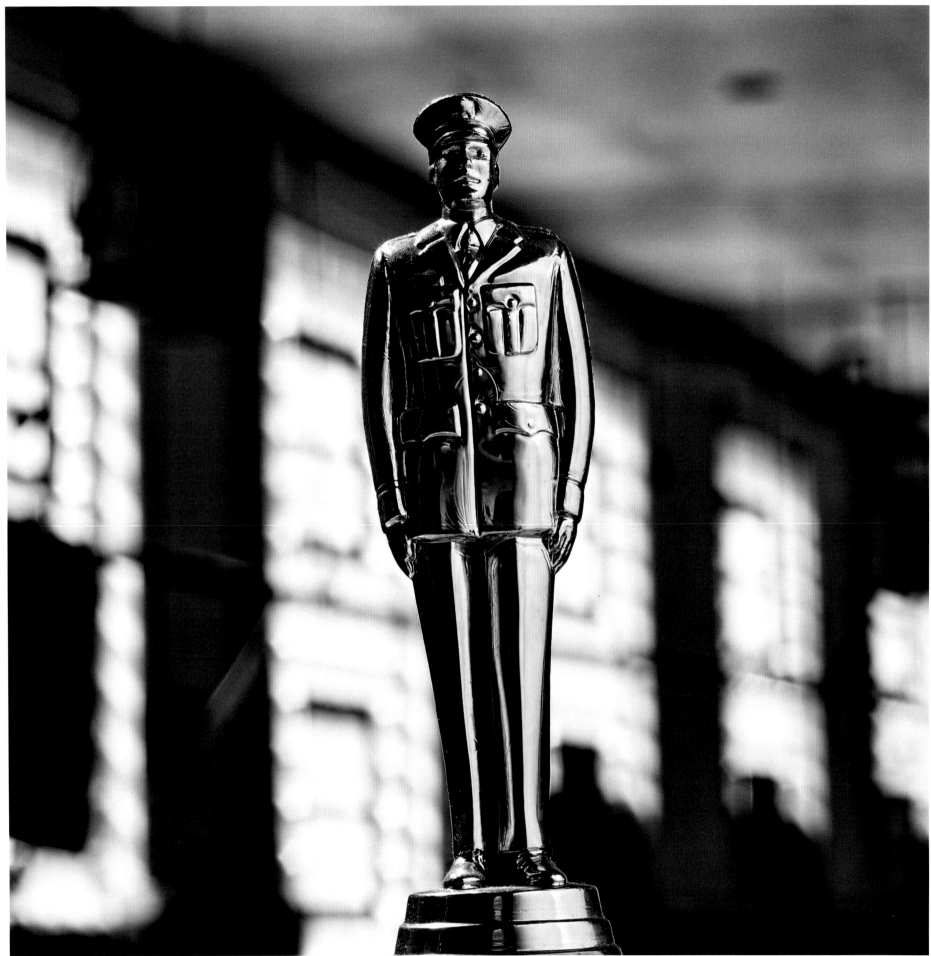

GUARD'S TROPHY

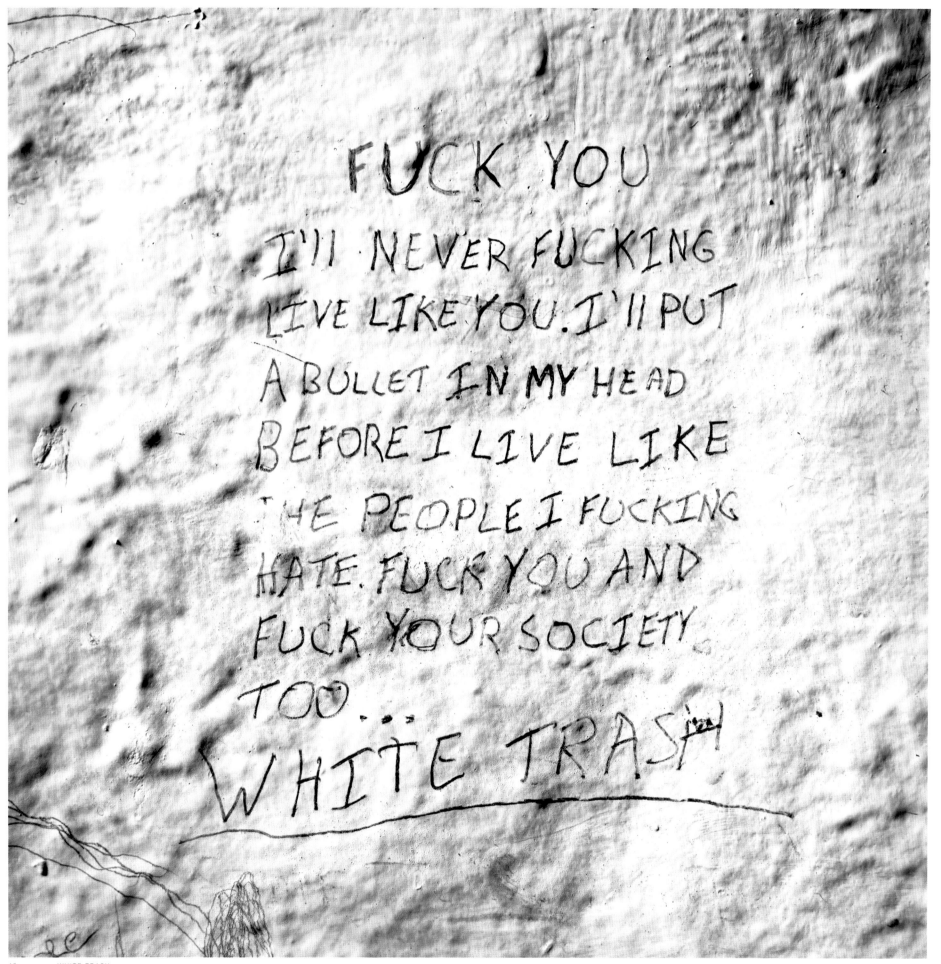

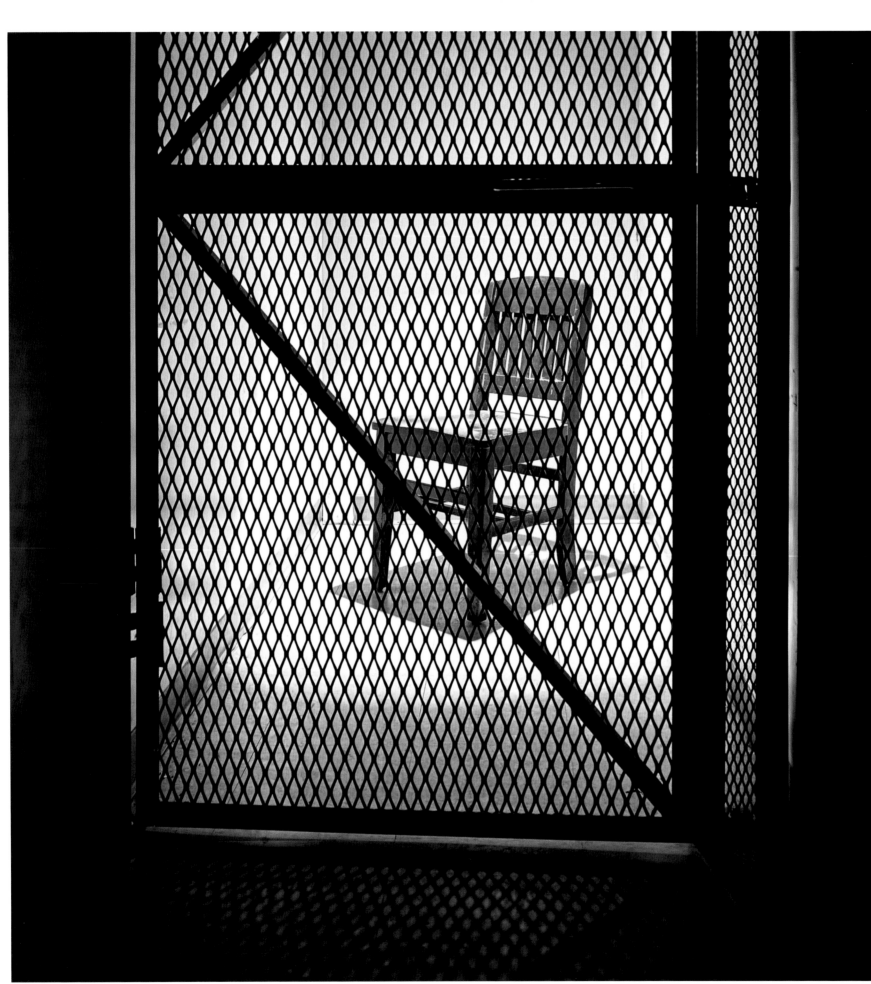

HOLDING PEN, 2006

THE CAGING OF AMERICA

Why do we lock up so many people?

BY ADAM GOPNIK

A prison is a trap for catching time. Good reporting appears often about the inner life of the American prison, but the catch is that American prison life is mostly undramatic — the reported stories fail to grab us, because, for the most part, nothing *happens*. One day in the life of Ivan Denisovich is all you need to know about Ivan Denisovich, because the idea that anyone could live for a minute in such circumstances seems impossible; one day in the life of an American prison means much less, because the force of it is that one day typically stretches out for decades. It isn't the horror of the time at hand but the unimaginable sameness of the time ahead that makes prisons unendurable for their inmates. The inmates on death row in Texas are called men in "timeless time," because they alone aren't serving time: they aren't waiting out five years or a decade or a lifetime. The basic reality of American prisons is not that of the lock and key but that of the lock and clock.

That's why no one who has been inside a prison, if only for a day, can ever forget the feeling. Time stops. A note of attenuated panic, of watchful paranoia — anxiety and boredom and fear mixed into a kind of enveloping fog, covering the guards as much as the guarded. "Sometimes I think this whole world is one big prison yard, / Some of us are prisoners, some of us are guards," Dylan sings, and while it isn't strictly true — just ask the prisoners — it contains a truth: the guards are doing time, too. As a smart man once wrote after being locked up, the thing about jail is that there are bars on the windows and they won't let you out. This simple truth governs all the others. What prisoners try to convey to the free is how the presence of time as something being done to you, instead of something you do things with, alters the mind at every moment. For American prisoners, huge numbers of whom are serving sentences much longer than those given for similar crimes anywhere else in the civilized world — Texas alone has sentenced more than four hundred teen-agers to life imprisonment — time becomes in every sense this thing you serve.

For most privileged, professional people, the experience of confinement is a mere brush, encountered after a kid's arrest, say. For a great many poor people in America, particularly poor black men, prison is a destination that braids through an ordinary life, much as high school and college do for rich white ones. More than half of all black men without a high-school diploma go to prison at some time in their lives. Mass incarceration on a scale almost unexampled in human history is a fundamental fact of our country today — perhaps *the* fundamental fact, as slavery was the fundamental fact of 1850. In truth, there are more black men in the grip of the criminal-justice system — in prison, on probation, or on parole — than were in slavery then. Over all, there are now more people under "correctional supervision" in America — more than six million — than were in the Gulag Archipelago under Stalin at its height. That city of the confined and the controlled, Lockuptown, is now the second largest in the United States.

The accelerating rate of incarceration over the past few decades is just as startling as the number of people jailed: in 1980, there were about two hundred and twenty people incarcerated for every hundred thousand Americans; by 2010, the number had more than tripled, to seven hundred and thirty-one. No other country even approaches that. In the past two decades, the money that states spend on prisons has risen at six times the rate of spending on higher education. Ours is, bottom to top, a "carceral state," in the flat verdict of Conrad Black, the former conservative press lord and newly minted reformer, who right now finds himself imprisoned in Florida, thereby adding a new twist to an old joke: A conservative is a liberal who's been mugged; a liberal is a conservative who's been indicted; and a passionate prison reformer is a conservative who's in one.

The scale and the brutality of our prisons are the moral scandal of American life. Every day, at least fifty thousand men—a full house at Yankee Stadium—wake in solitary confinement, often in "supermax" prisons or prison wings, in which men are locked in small cells, where they see no one, cannot freely read and write, and are allowed out just once a day for an hour's solo "exercise." (Lock yourself in your bathroom and then imagine you have to stay there for the next ten years, and you will have some sense of the experience.) Prison rape is so endemic—more than seventy thousand prisoners are raped each year—that it is routinely held out as a threat, part of the punishment to be expected. The subject is standard fodder for comedy, and an uncoöperative suspect being threatened with rape in prison is now represented, every night on television, as an ordinary and rather lovable bit of policing. The normalization of prison rape—like eighteenth-century japery about watching men struggle as they die on the gallows—will surely strike our descendants as chillingly sadistic, incomprehensible on the part of people who thought themselves civilized. Though we avoid looking directly at prisons, they seep obliquely into our fashions and manners. Wealthy white teen-agers in baggy jeans and laceless shoes and multiple tattoos show, unconsciously, the reality of incarceration that acts as a hidden foundation for the country.

How did we get here? How is it that our civilization, which rejects hanging and flogging and disembowelling, came to believe that caging vast numbers of people for decades is an acceptably humane sanction? There's a fairly large recent scholarly literature on the history and sociology of crime and punishment, and it tends to trace the American zeal for punishment back to the nineteenth century, apportioning blame in two directions. There's an essentially Northern explanation, focussing on the inheritance of the notorious Eastern State Penitentiary, in Philadelphia, and its "reformist" tradition; and a Southern explanation, which sees the prison system as essentially a slave planta-tion continued by other means. Robert Perkinson, the author of the Southern revisionist tract "Texas Tough: The Rise of America's Prison Empire," traces two ancestral lines, "from the North, the birthplace of rehabilitative penology, to the South, the fountainhead of subjugationist discipline." In other words, there's the scientific taste for reducing men to numbers and the slave owners' urge to reduce blacks to brutes.

William J. Stuntz, a professor at Harvard Law School who died shortly before his masterwork, "The Collapse of American Criminal Justice," was published, last fall, is the most forceful advocate for the view that the scandal of our prisons derives from the Enlightenment-era, "procedural" nature of American justice. He runs through the immediate causes of the incarceration epidemic: the growth of post-Rockefeller drug laws, which punished minor drug offenses with major prison time; "zero tolerance" policing, which added to the group; mandatory-sentencing laws, which prevented judges from exercising judgment. But his search for the ultimate cause leads deeper, all the way to the Bill of Rights. In a society where Constitution worship is still a requisite on right and left alike, Stuntz startlingly suggests that the Bill of Rights is a terrible document with which to start a justice system—much inferior to the exactly contemporary French Declaration of the Rights of Man, which Jefferson, he points out, may have helped shape while his protégé Madison was writing ours.

The trouble with the Bill of Rights, he argues, is that it emphasizes process and procedure rather than principles. The Declaration of the Rights of Man says, Be just! The Bill of Rights says, Be fair! Instead of announcing general principles—no one should be accused of some-thing that wasn't a crime when he did it; cruel punishments are always wrong; the goal of justice is, above all, that justice be done—it talks procedurally. You can't search someone without a reason; you can't accuse him without allowing him to see the evidence; and so on. This

emphasis, Stuntz thinks, has led to the current mess, where accused criminals get laboriously articulated protection against procedural errors and no protection at all against outrageous and obvious violations of simple justice. You can get off if the cops looked in the wrong car with the wrong warrant when they found your joint, but you have no recourse if owning the joint gets you locked up for life. You may be spared the death penalty if you can show a problem with your appointed defender, but it is much harder if there is merely enormous accumulated evidence that you weren't guilty in the first place and the jury got it wrong. Even clauses that Americans are taught to revere are, Stuntz maintains, unworthy of reverence: the ban on "cruel and unusual punishment" was designed to *protect* cruel punishments—flogging and branding—that were not at that time unusual.

The obsession with due process and the cult of brutal prisons, the argument goes, share an essential impersonality. The more professionalized and procedural a system is, the more insulated we become from its real effects on real people. That's why America is famous both for its process-driven judicial system ("The bastard got off on a technicality," the cop-show detective fumes) and for the harshness and inhumanity of its prisons. Though all industrialized societies started sending more people to prison and fewer to the gallows in the eighteenth century, it was in Enlightenment-inspired America that the taste for long-term, profoundly depersonalized punishment became most aggravated. The inhumanity of American prisons was as much a theme for Dickens, visiting America in 1842, as the cynicism of American lawyers. His shock when he saw the Eastern State Penitentiary, in Philadelphia—a "model" prison, at the time the most expensive public building ever constructed in the country, where every prisoner was kept in silent, separate confinement—still resonates:

> I believe that very few men are capable of estimating the immense amount of torture and agony which this dreadful punishment, prolonged for years, inflicts upon the sufferers.… I hold this slow and daily tampering with the mysteries of the brain, to be immeasurably worse than any torture of the body: and because its ghastly signs and tokens are not so palpable to the eye and sense of touch as scars upon the flesh; because its wounds are not upon the surface, and it extorts few cries that human ears can hear; therefore I the more denounce it, as a secret punishment which slumbering humanity is not roused up to stay.

Not roused up to stay—that was the point. Once the procedure ends, the penalty begins, and, as long as the cruelty is routine, our civil responsibility toward the punished is over. We lock men up and forget about their existence. For Dickens, even the corrupt but communal debtors' prisons of old London were better than *this*. "Don't take it personally!"—that remains the slogan above the gate to the American prison Inferno. Nor is this merely a historian's vision. Conrad Black, at the high end, has a scary and persuasive picture of how his counsel, the judge, and the prosecutors all merrily congratulated each other on their combined professional excellence just before sending him off to the hoosegow for several years. If a millionaire feels that way, imagine how the ordinary culprit must feel.

In place of abstraction, Stuntz argues for the saving grace of humane discretion. Basically, he thinks, we should go into court with an understanding of what a crime is and what justice is like, and then let common sense and compassion and specific circumstance take over. There's a lovely scene in "The Castle," the Australian movie about a family fighting eminent-domain eviction, where its hapless lawyer, asked in court to point to the specific part of the Australian constitution that the eviction violates, says desperately, "It's…just the *vibe* of the thing." For Stuntz, justice ought to be just the vibe of the thing—not one procedural error caught or one fact worked around. The criminal law should once again be more like the common law, with judges and juries not merely finding fact but making law on the basis of universal principles of fairness, circumstance, and seriousness, and crafting penalties to the exigencies of the crime.

The other argument—the Southern argument—is that this story puts too bright a face on the truth. The reality of American prisons, this argument runs, has nothing to do with the knots of procedural justice or the perversions of Enlightenment-era ideals. Prisons today operate less in the rehabilitative mode of the Northern reformers "than in a retributive mode that has long been practiced and promoted in the South," Perkinson, an American-studies professor, writes. "American prisons trace their lineage not only back to Pennsylvania penitentiaries but to Texas slave plantations." White supremacy is the real principle, this thesis holds, and racial domination the real end. In response to the apparent triumphs of the sixties, mass imprisonment became a way of reimposing Jim Crow. Blacks are now incarcerated seven times as often as whites. "The system of mass incarceration works to trap African Americans in a virtual (and literal) cage," the legal scholar

Michelle Alexander writes. Young black men pass quickly from a period of police harassment into a period of "formal control" (i.e., actual imprisonment) and then are doomed for life to a system of "invisible control." Prevented from voting, legally discriminated against for the rest of their lives, most will cycle back through the prison system. The system, in this view, is not really broken; it is doing what it was designed to do. Alexander's grim conclusion: "If mass incarceration is considered as a system of social control—specifically, racial control—then the system is a fantastic success."

Northern impersonality and Southern revenge converge on a common American theme: a growing number of American prisons are now contracted out as for-profit businesses to for-profit companies. The companies are paid by the state, and their profit depends on spending as little as possible on the prisoners and the prisons. It's hard to imagine any greater disconnect between public good and private profit: the interest of private prisons lies not in the obvious social good of having the minimum necessary number of inmates but in having as many as possible, housed as cheaply as possible. No more chilling document exists in recent American life than the 2005 annual report of the biggest of these firms, the Corrections Corporation of America. Here the company (which spends millions lobbying legislators) is obliged to caution its investors about the risk that somehow, somewhere, someone might turn off the spigot of convicted men:

> Our growth is generally dependent upon our ability to obtain new contracts to develop and manage new correctional and detention facilities….The demand for our facilities and services could be adversely affected by the relaxation of enforcement efforts, leniency in conviction and sentencing practices or through the decriminalization of certain activities that are currently proscribed by our criminal laws. For instance, any changes with respect to drugs and controlled substances or illegal immigration could affect the number of persons arrested, convicted, and sentenced, thereby potentially reducing demand for correctional facilities to house them.

Brecht could hardly have imagined such a document: a capitalist enterprise that feeds on the misery of man trying as hard as it can to be sure that nothing is done to decrease that misery.

Yet a spectre haunts all these accounts, North and South, whether process gone mad or penal colony writ large. It is that the epidemic of imprisonment seems to track the dramatic decline in crime over the same period. The more bad guys there are in prison, it appears, the less crime there has been in the streets. The real background to the prison boom, which shows up only sporadically in the prison literature, is the crime wave that preceded and overlapped it.

For those too young to recall the big-city crime wave of the sixties and seventies, it may seem like mere bogeyman history. For those whose entire childhood and adolescence were set against it, it is the crucial trauma in recent American life and explains much else that happened in the same period. It was the condition of the Upper West Side of Manhattan under liberal rule, far more than what had happened to Eastern Europe under socialism, that made neo-con polemics look persuasive. There really was, as Stuntz himself says, a liberal consensus on crime ("Wherever the line is between a merciful justice system and one that abandons all serious effort at crime control, the nation had crossed it"), and it really did have bad effects.

Yet if, in 1980, someone had predicted that by 2012 New York City would have a crime rate so low that violent crime would have largely disappeared as a subject of conversation, he would have seemed not so much hopeful as crazy. Thirty years ago, crime was supposed to be a permanent feature of the city, produced by an alienated underclass of super-predators; now it isn't. Something good happened to change it, and you might have supposed that the change would be an opportunity for celebration and optimism. Instead, we mostly content ourselves with grudging and sardonic references to the silly side of gentrification, along with a few all-purpose explanations, like broken-window policing. This is a general human truth: things that work interest us less than things that don't.

So what *is* the relation between mass incarceration and the decrease in crime? Certainly, in the nineteen-seventies and eighties, many experts became persuaded that there was no way to make bad people better; all you could do was warehouse them, for longer or shorter periods. The best research seemed to show, depressingly, that nothing works—that rehabilitation was a ruse. Then, in 1983, inmates at the maximum-security federal prison in Marion, Illinois, murdered two guards. Inmates had been (very occasionally) killing guards for a long time, but the timing of the murders, and the fact that they took place in

a climate already prepared to believe that even ordinary humanity was wasted on the criminal classes, meant that the entire prison was put on permanent lockdown. A century and a half after absolute solitary first appeared in American prisons, it was reintroduced. Those terrible numbers began to grow.

And then, a decade later, crime started falling: across the country by a standard measure of about forty per cent; in New York City by as much as eighty per cent. By 2010, the crime rate in New York had seen its greatest decline since the Second World War; in 2002, there were fewer murders in Manhattan than there had been in any year since 1900. In social science, a cause sought is usually a muddle found; in life as we experience it, a crisis resolved is causality established. If a pill cures a headache, we do not ask too often if the headache might have gone away by itself.

All this ought to make the publication of Franklin E. Zimring's new book, "The City That Became Safe," a very big event. Zimring, a criminologist at Berkeley Law, has spent years crunching the numbers of what happened in New York in the context of what happened in the rest of America. One thing he teaches us is how little we know. The forty per cent drop across the continent — indeed, there was a decline throughout the Western world — took place for reasons that are as mysterious in suburban Ottawa as they are in the South Bronx. Zimring shows that the usual explanations — including demographic shifts — simply can't account for what must be accounted for. This makes the international decline look slightly eerie: blackbirds drop from the sky, plagues slacken and end, and there seems no absolute reason that societies leap from one state to another over time. Trends and fashions and fads and pure contingencies happen in other parts of our social existence; it may be that there are fashions and cycles in criminal behavior, too, for reasons that are just as arbitrary.

But the additional forty per cent drop in crime that seems peculiar to New York finally succumbs to Zimring's analysis. The change didn't come from resolving the deep pathologies that the right fixated on — from jailing super predators, driving down the number of unwed mothers, altering welfare culture. Nor were there cures for the underlying causes pointed to by the left: injustice, discrimination, poverty. Nor were there any "Presto!" effects arising from secret patterns of increased abortions or the like. The city didn't get much richer; it didn't get much poorer. There was no significant change in the

ethnic makeup or the average wealth or educational levels of New Yorkers as violent crime more or less vanished. "Broken windows" or "turnstile jumping" policing, that is, cracking down on small visible offenses in order to create an atmosphere that refused to license crime, seems to have had a negligible effect; there was, Zimring writes, a great difference between the slogans and the substance of the time. (Arrests for "visible" nonviolent crime — e.g., street prostitution and public gambling — mostly went *down* through the period.)

Instead, small acts of social engineering, designed simply to stop crimes from happening, helped stop crime. In the nineties, the N.Y.P.D. began to control crime not by fighting minor crimes in safe places but by putting lots of cops in places where lots of crimes happened — "hot-spot policing." The cops also began an aggressive, controversial program of "stop and frisk" — "designed to catch the sharks, not the dolphins," as Jack Maple, one of its originators, described it — that involved what's called pejoratively "profiling." This was not so much racial, since in any given neighborhood all the suspects were likely to be of the same race or color, as social, involving the thousand small clues that policemen recognized already. Minority communities, Zimring emphasizes, paid a disproportionate price in kids stopped and frisked, and detained, but they also earned a disproportionate gain in crime reduced. "The poor pay more and get more" is Zimring's way of putting it. He believes that a "light" program of stop-and-frisk could be less alienating and just as effective, and that by bringing down urban crime stop-and-frisk had the net effect of greatly reducing the number of poor minority kids in prison for long stretches.

Zimring insists, plausibly, that he is offering a radical and optimistic rewriting of theories of what crime is and where criminals are, not least because it disconnects crime and minorities. "In 1961, twenty six percent of New York City's population was minority African American or Hispanic. Now, half of New York's population is — and what that does in an enormously hopeful way is to destroy the rude assumptions of supply side criminology," he says. By "supply side criminology," he means the conservative theory of crime that claimed that social circumstances produced a certain net amount of crime waiting to be expressed; if you stopped it here, it broke out there. The only way to stop crime was to lock up all the potential criminals. In truth, criminal activity seems like most other human choices — a question of contingent occasions and opportunity. Crime is not the consequence of a set number of criminals; criminals are the consequence of a set number

of opportunities to commit crimes. Close down the open drug market in Washington Square, and it does not automatically migrate to Tompkins Square Park. It just stops, or the dealers go indoors, where dealing goes on but violent crime does not.

And, in a virtuous cycle, the decreased prevalence of crime fuels a decrease in the prevalence of crime. When your friends are no longer doing street robberies, you're less likely to do them. Zimring said, in a recent interview, "Remember, nobody ever made a living mugging. There's no minimum wage in violent crime." In a sense, he argues, it's recreational, part of a life style: "Crime is a routine behavior; it's a thing people do when they get used to doing it." And therein lies its essential fragility. Crime ends as a result of "cyclical forces operating on situational and contingent things rather than from finding deeply motivated essential linkages." Conservatives don't like this view because it shows that being tough doesn't help; liberals don't like it because apparently being nice doesn't help, either. Curbing crime does not depend on reversing social pathologies or alleviating social grievances; it depends on erecting small, annoying barriers to entry.

One fact stands out. While the rest of the country, over the same twenty-year period, saw the growth in incarceration that led to our current astonishing numbers, New York, despite the Rockefeller drug laws, saw a marked decrease in its number of inmates. "New York City, in the midst of a dramatic reduction in crime, is locking up a much smaller number of people, and particularly of young people, than it was at the height of the crime wave," Zimring observes. Whatever happened to make street crime fall, it had nothing to do with putting more men in prison. The logic is self-evident if we just transfer it to the realm of white-collar crime: we easily accept that there is no net sum of white-collar crime waiting to happen, no inscrutable generation of super-predators produced by Dewar's-guzzling dads and scaly M.B.A. profs; if you stop an embezzlement scheme here on Third Avenue, another doesn't naturally start in the next office building. White-collar crime happens through an intersection of pathology and opportunity; getting the S.E.C. busy ending the opportunity is a good way to limit the range of the pathology.

Social trends deeper and less visible to us may appear as future historians analyze what went on. Something other than policing may explain things—just as the coming of cheap credit cards and state lotteries probably did as much to weaken the Mafia's Five Families in New York,

who had depended on loan sharking and numbers running, as the F.B.I. could. It is at least possible, for instance, that the coming of the mobile phone helped drive drug dealing indoors, in ways that helped drive down crime. It may be that the real value of hot spot and stop-and-frisk was that it provided a single game plan that the police believed in; as military history reveals, a bad plan is often better than no plan, especially if the people on the other side think it's a good plan. But one thing is sure: social epidemics, of crime or of punishment, can be cured more quickly than we might hope with simpler and more superficial mechanisms than we imagine. Throwing a Band-Aid over a bad wound is actually a decent strategy, if the Band-Aid helps the wound to heal itself.

Which leads, further, to one piece of radical common sense: since prison plays at best a small role in stopping even violent crime, very few people, rich or poor, should be in prison for a nonviolent crime. Neither the streets nor the society is made safer by having marijuana users or peddlers locked up, let alone with the horrific sentences now dispensed so easily. For that matter, no social good is served by having the embezzler or the Ponzi schemer locked in a cage for the rest of his life, rather than having him bankrupt and doing community service in the South Bronx for the next decade or two. Would we actually have more fraud and looting of shareholder value if the perpetrators knew that they would lose their bank accounts and their reputation, and have to do community service seven days a week for five years? It seems likely that anyone for whom those sanctions aren't sufficient is someone for whom no sanctions are ever going to be sufficient. Zimring's research shows clearly that, if crime drops on the street, criminals coming out of prison stop committing crimes. What matters is the incidence of crime in the world, and the continuity of a culture of crime, not some "lesson learned" in prison.

At the same time, the ugly side of stop-and-frisk can be alleviated. To catch sharks and not dolphins, Zimring's work suggests, we need to adjust the size of the holes in the nets—to make crimes that are the occasion for stop-and-frisks real crimes, not crimes like marijuana possession. When the New York City police stopped and frisked kids, the main goal was not to jail them for having pot but to get their fingerprints, so that they could be identified if they committed a more serious crime. But all over America the opposite happens: marijuana possession becomes the serious crime. The cost is so enormous,

though, in lives ruined and money spent, that the obvious thing to do is not to enforce the law less but to change it now. Dr. Johnson said once that manners make law, and that when manners alter, the law must, too. It's obvious that marijuana is now an almost universally accepted drug in America: it is not only used casually (which has been true for decades) but also talked about casually on television and in the movies (which has not). One need only watch any stoner movie to see that the perceived risks of smoking dope are not that you'll get arrested but that you'll get in trouble with a rival frat or look like an idiot to women. The decriminalization of marijuana would help end the epidemic of imprisonment.

The rate of incarceration in most other rich, free countries, whatever the differences in their histories, is remarkably steady. In countries with Napoleonic justice or common law or some mixture of the two, in countries with adversarial systems and in those with magisterial ones, whether the country once had brutal plantation-style penal colonies, as France did, or was once itself a brutal plantation-style penal colony, like Australia, the natural rate of incarceration seems to hover right around a hundred men per hundred thousand people. (That doesn't mean it doesn't get lower in rich, homogeneous countries—just that it never gets much higher in countries otherwise like our own.) It seems that one man in every thousand once in a while does a truly bad thing. All other things being equal, the point of a justice system should be to identify that thousandth guy, find a way to keep him from harming other people, and give everyone else a break.

E pidemics seldom end with miracle cures. Most of the time in the history of medicine, the best way to end disease was to build a better sewer and get people to wash their hands. "Merely chipping away at the problem around the edges" is usually the very best thing to do with a problem; keep chipping away patiently and, eventually, you get to its heart. To read the literature on crime before it dropped is to see the same kind of dystopian despair we find in the new literature of punishment: we'd have to end poverty, or eradicate the ghettos, or declare war on the broken family, or the like, in order to end the crime wave. The truth is, a series of small actions and events ended up eliminating a problem that seemed to hang over everything. There was no miracle cure, just the intercession of a thousand smaller sanities. Ending sentencing for drug misdemeanors, decriminalizing marijuana, leaving judges free to use common sense (and, where possible, getting judges who are judges rather than politicians)—many small acts are possible that will help end the epidemic of imprisonment as they helped end the plague of crime.

"Oh, I have taken too little care of this!" King Lear cries out on the heath in his moment of vision. "Take physic, pomp; expose thyself to feel what wretches feel." "This" changes; in Shakespeare's time, it was flat-out peasant poverty that starved some and drove others as mad as poor Tom. In Dickens's and Hugo's time, it was the industrial revolution that drove kids to mines. But every society has a poor storm that wretches suffer in, and the attitude is always the same: either that the wretches, already dehumanized by their suffering, deserve no pity or that the oppressed, overwhelmed by injustice, will have to wait for a better world. At every moment, the injustice seems inseparable from the community's life, and in every case the arguments for keeping the system in place were that you would have to revolutionize the entire social order to change it—which then became the argument for revolutionizing the entire social order. In every case, humanity and common sense made the insoluble problem just get up and go away. Prisons are our this. We need take more care.

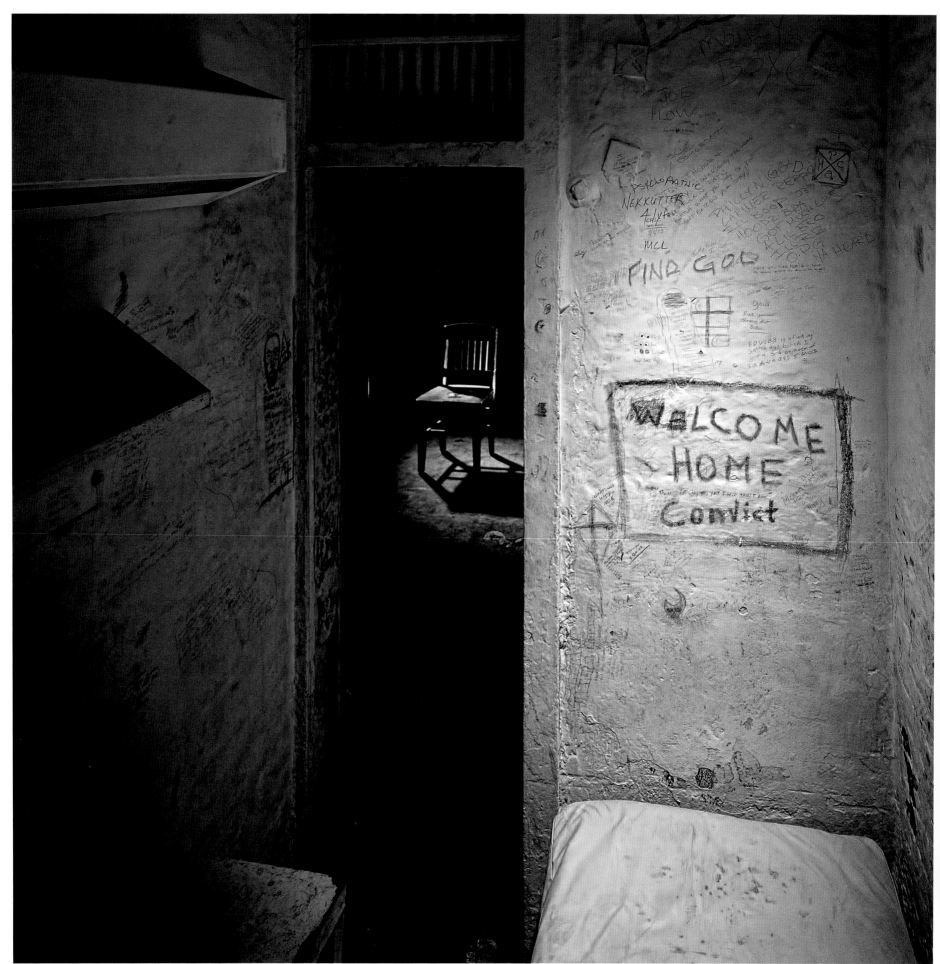

THEY WILL
CONTINUE
OPENING THE
GATE FOR YOU
AS LONG AS
YOU CONTINUE
TO MAKE THE
WRONG CHOICE.

HOW DO YOU
WANT TO LIVE
THE REST OF
YOUR LIFE.
IN AND OUT
OR
OUT FOR GOOD.
— OUT

READ THIS.
CRYING ASS SHIT
ON THE WALL.
BITCH ASS SURVIVAL.
WHAT'S UP.
WHAT YOU GOING
TO TELL YOUR KIDS
WHEN YOU'RE
ALREADY BROKE.
BITCH N.S

I'M AT WESTERN.
I'LL NEVER LEARN.
RIDE TILL THE
DAY I DIE.
THOROBRED
WITH BIG FIGURES.
ITCHY TRIGGER
FINGER, DOIN A
DUCE AND A HALF.
A, FUCK IT.
I'M DOIN A MAX,
DOIN ALL FIVE.
ERIE 4 LIFE

WRITE YOUR NAME
ON THESE WALLS
AND YOU ARE
SURE TO RE-
TURN ONE DAY!

FOR I HAVE
RETURNED!

11½ – 40 (2-27-88 TO 2-27-98)

12-25-03

241

CELL

149

CELL

All men are equal.
Why hate?

R.I.P. Shane sentenced
to life and hung up
first night here.

It better to have loved
and lost than never have
loved at all.

Innocent for real —
framed with phoney
evidence, testimony from
lying Allegheny County
Cops and other County
employees, and given a
court appointed lawyer
who was in league
with the D.A.'s office
(and Satan) accept a
plea of 3½ to 7 or
my wife was/is innocent
would spend the next
5 to 10 years in jail!

A conspiracy! Yes!
Why?
I don't know. I used to
think the system worked
— but it's as crooked
as it can get.

A lot of lawyers don't care
about you, they get paid
whether they win or lose.
So what! Fuck the lawyers,
let's suck cock.

YOUNG 18–25 YEARS

IF YOU SMOKE, DO YOURSELF A FAVOR, AND QUIT NOW. DON'T PUT YOURSELF THROUGH THE SHAME OF BEGGING. FIRST SIX DAYS ARE A BITCH, BUT AFTER THE SIXTH DAY YOU GOT IT LICKED.

THE LIGHT SHINES IN THE DARKNESS, BUT THE DARKNESS HAS NOT UNDERSTOOD.

TIME IS MY GREATEST ENEMIE. I LEARNED THAT THE HARD WAY. YEARS IS PASSING TOO SHORT FOR A LONG STAY. THESE PRISON WALLS MAKE YOUR HEART FILL WITH VANITY, INIQUITY'S TAKEN OVER OUR SOULS. CAN'T LET IT CAPTURE ME.

ROY 9-20-03

A NOTE FROM A P.V. FOR ALL FIRST TIMERS TO COME. IF YOU DON'T HAVE LIFE AND ARE GOING TO SEE THE STREET AGAIN SOMEDAY. DON'T FUCK IT UP IT'S HARDER COMING BACK THROUGH THE SECOND TIME. LEARN ALL THAT YOU CAN FROM YOUR STAY TO PREPARE FOR YOUR FUTURE.

YOUR FATHERS THE MAN, THE GOD, THE JUDGE THAT GOT YOUR SENTENCE REDUCED. BUT IN THE BACK OF HIS MIND. WHO KNOWS WHAT HE'LL FIND IF HE LOOKS A LITTLE DEEPER IN YOUR DEEP WATERS OF WAR.

GLENN 10-2-02

I ASKED JESUS HOW MUCH HE LOVED ME? AND HE SAID THIS MUCH AND SPREAD OUT HIS ARMS AND DIED.

TWO BLONDES WALK INTO A BANK! YOU FIGURE ONE OF THEM WOULD HAVE SEEN IT. HA, HA.

THE PAIN WE PUT OUR MOTHERS THROUGH?

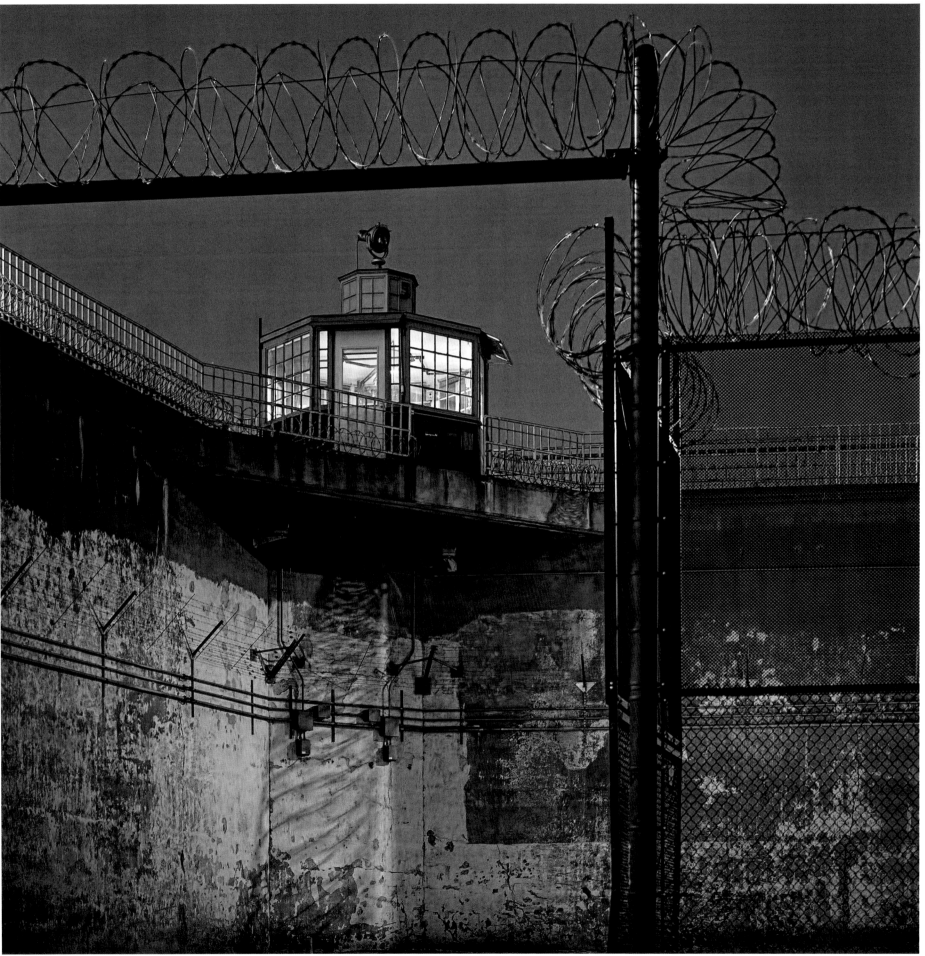

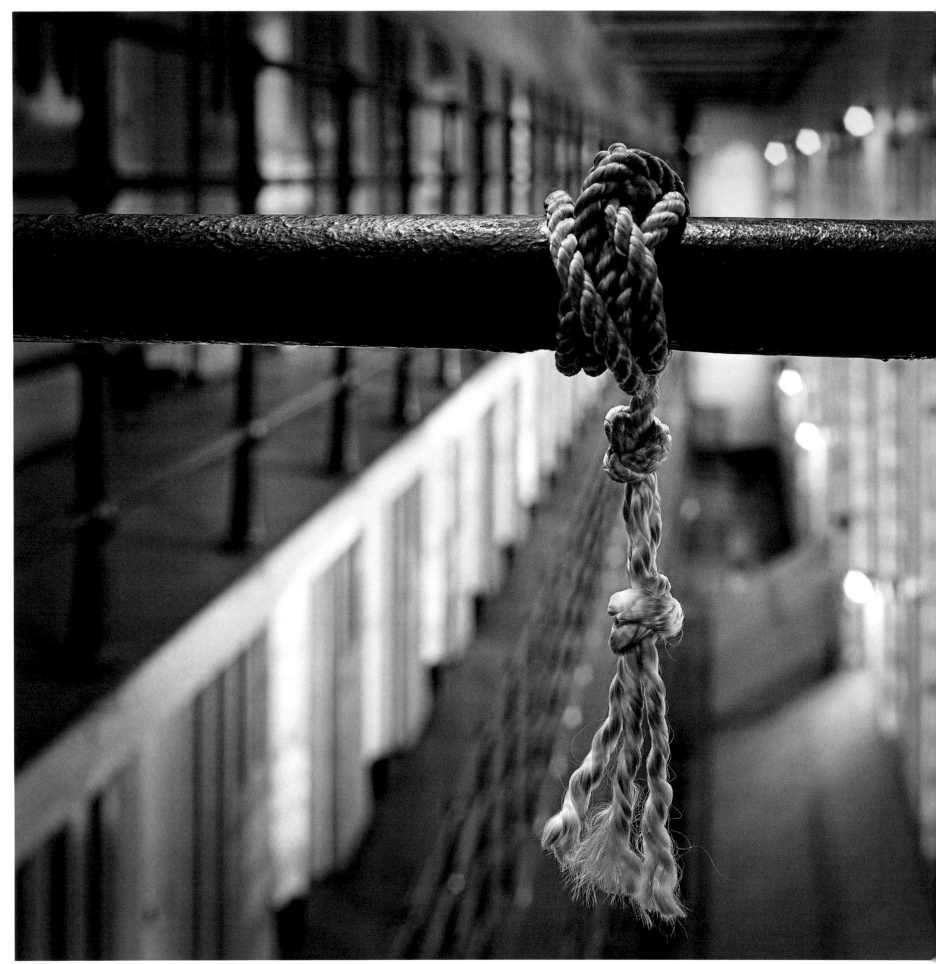

ROPE, E BLOCK, 2005

CELL

CELL

If you're a baby raper
you will die in seven days
after reading this you will
hang up or I will haunt
you forever and ever.

Like Bill G. of Franklin, PA,
now of Albion C.I. Let him
know if you hear this
name. Someone's going
to kill him.

Stand on the bed,
the view is different.

TIP #2
WORDS OF
ADVICE:
IF PAROLED
DON'T GO TO
THE 1/2 WAY
HOUSE OR
A CENTER
ITS ONLY
PAROLES WAY
OF GIVING YOU
A ROPE TO
HANG
YOURSELF.
THEY'LL SEND
YOU BACK FOR
JUST ABOUT
ANYTHING.
IF AT ALL
POSSIBLE
MAX OUT!!!

262

CELL

250

CELL

If you're a black boy don't go to F block. If you do go that's where they turn you into a fuck toy.

You made a wrong turn some-where.

Doin time ain't hard, what's hard is gettin' out. Once you get out, **STAY OUT.**

I'm a woman trapped in a man's body. It cost for a sex change $5000. You can only get it done in Colorado.

Why me? Because I needed money.

All you nigers listen up...This is a white country. Get back on the boat, and go the next boming will be against you all remember about 9/11.

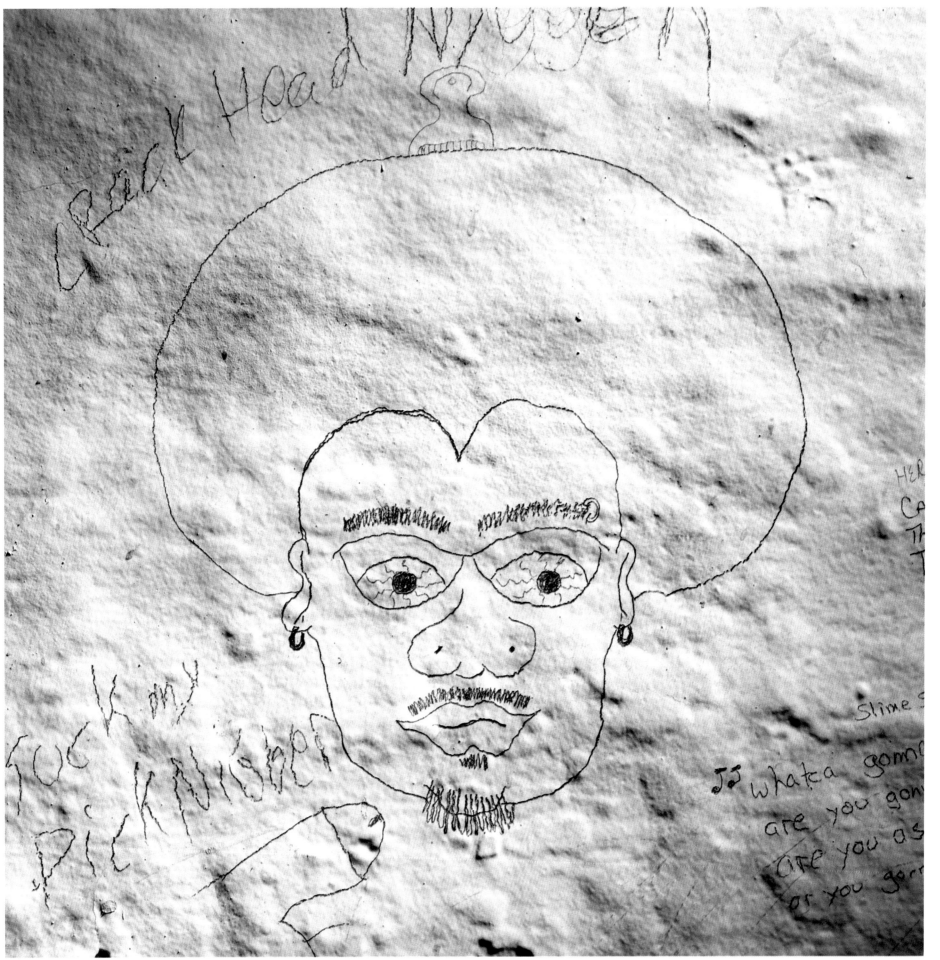

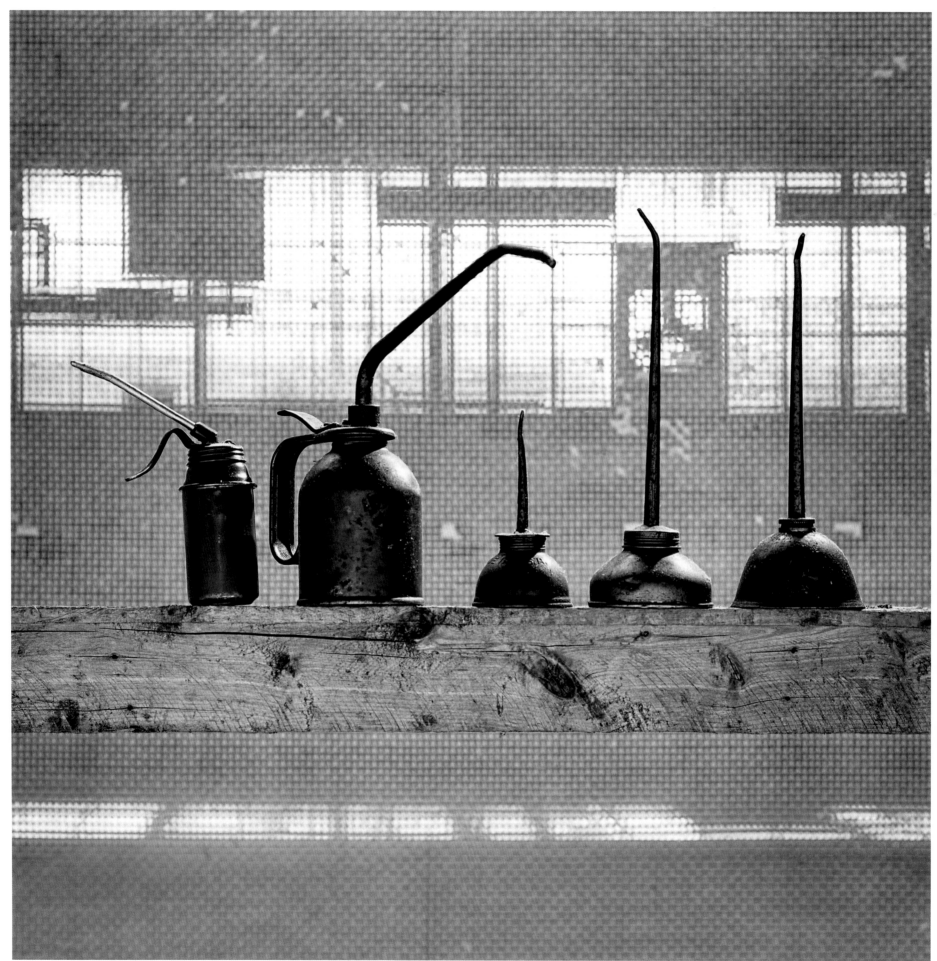

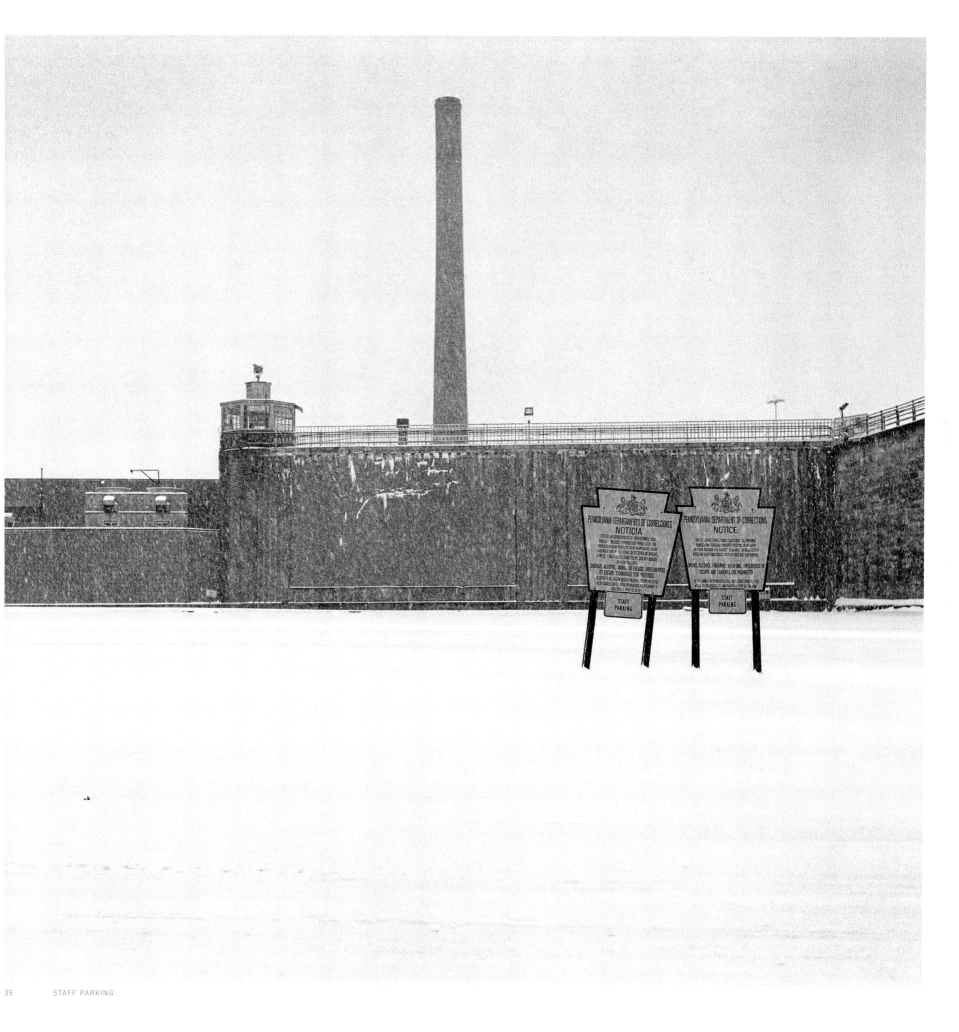

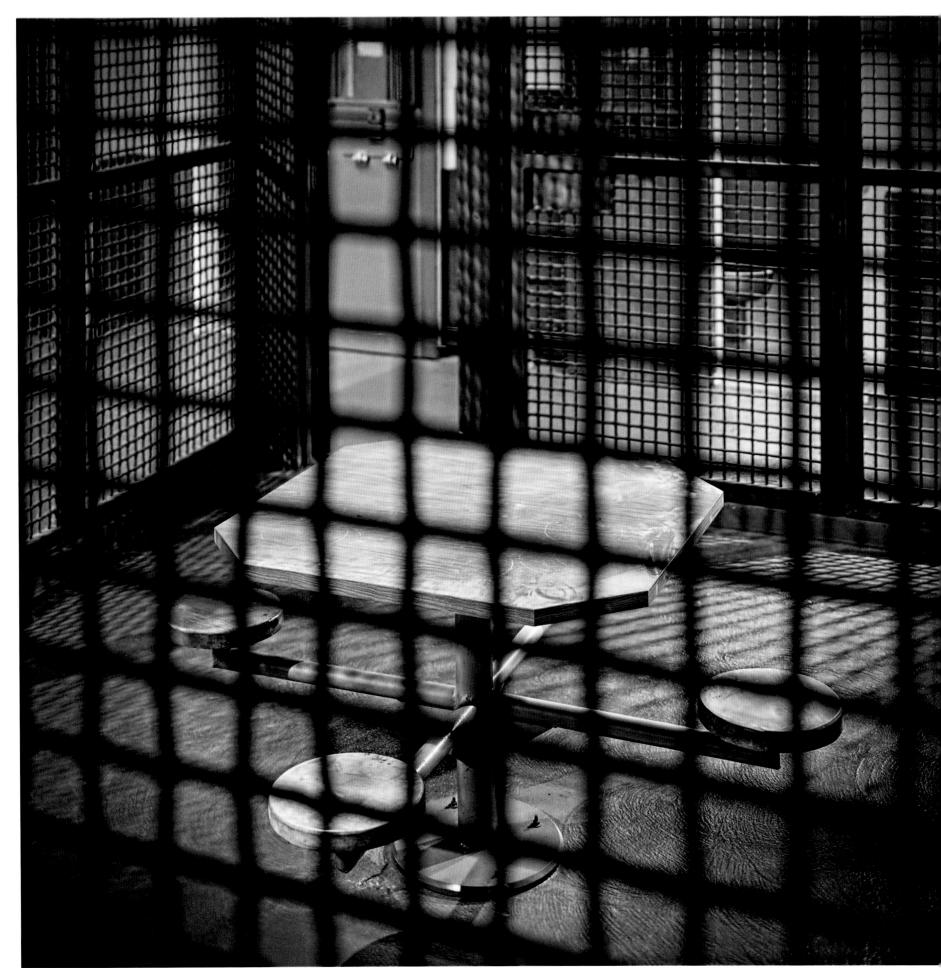

DAY ROOM, DEATH ROW

2003

January

	Mon	Tue	WEB	THUR	FRI	SAT
					1	2
4	5	6	7	8	9	Hopefully ←
11	12	13	14	15	16	
18	19	20	21	22	23	
25	26	27	28	29	30	

Febuary

1	2	3	4	5	6	
8	9	10	11	12	13	
15	16	17	18	19	20	
22	23	24	25	26	27	
29						

MARCH

1	2	3	4	5	
7	8	9	10	11	12

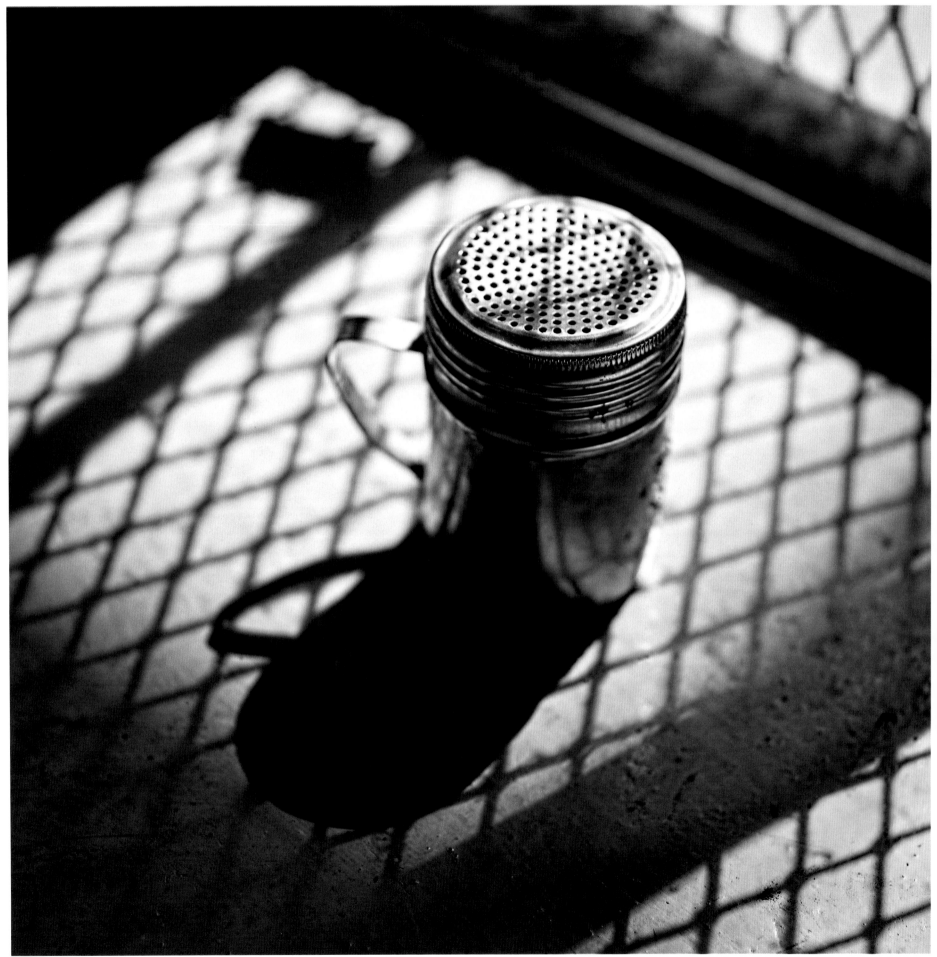

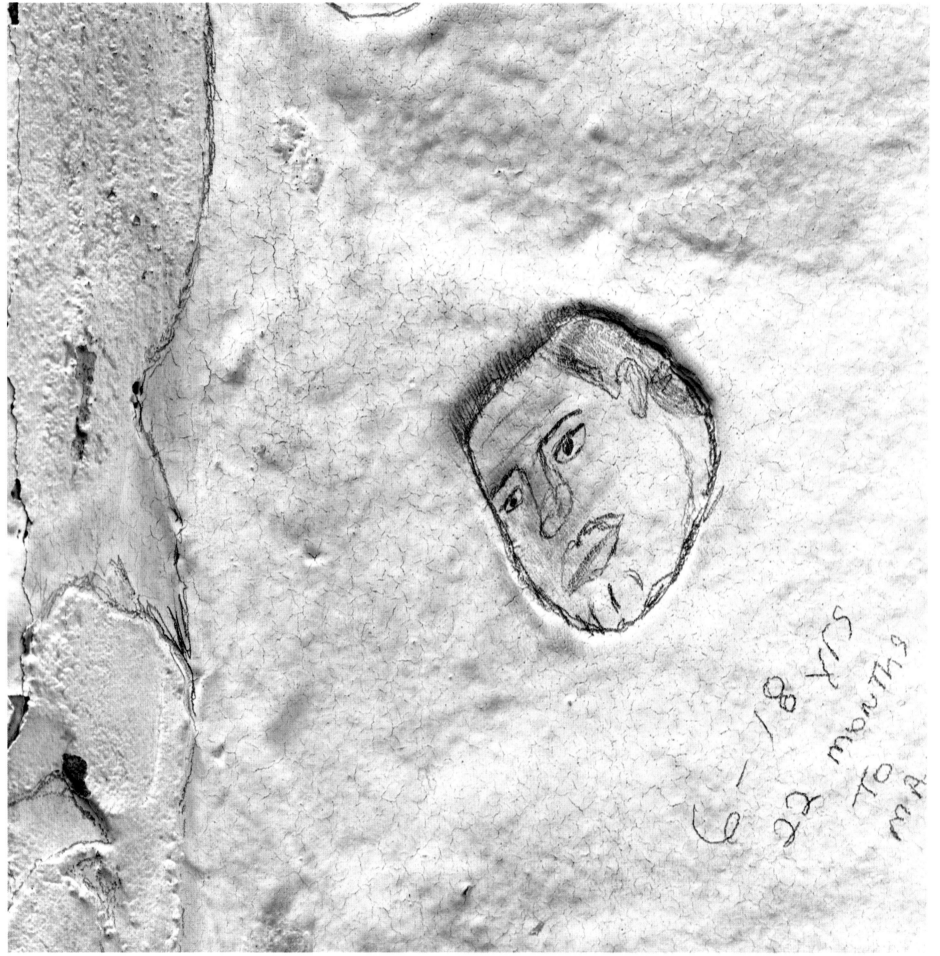

Bitches use guns cause they can't fight like men. **Stupid boyz.** Maybe one day those guns will cap your mommas ass or your sisters ass, maybe even your baby's ass.

GENIUS SAYS THERE IS NO SMART WAY TO HUSTLE, YOU WILL ALWAYS END UP IN THIS STRUGGLE. J.R. IS THE BEST POET.

IF YOU'RE SCARED SAY YOU'RE SCARED. JUST QUIT YOUR DAMNED CRYING!!!

IT'S NOT THE COUNTIES IN PA THAT YOU NEED TO STAY OUT OF. YOU NEED TO STAY AWAY FROM PA TOTALLY.
STAY OUT OF BUTLER COUNTY, A.K.A. HAZARD COUNTY. THE WHOLE COUNTY IS CORRUPT.
STAY OUT OF VENANGO.
STAY OUT OF FAYETTE — NAM.
STAY OUT OF ERIE COUNTY,
STAY OUT OF CLEARFIELD COUNTY,
STAY OUT OF ALLEGHENY COUNTY, THE WORST. AND CRAWFORD COUNTY,
STAY OUT OF VENANGO COUNTY,
STAY OUT OF JAIL PERIOD.

YOU ARE GONE BUT NOT FORGOTTEN. YOU WILL ALWAYS BE IN MY DRAWING OF HEART.
R.I.P. REGINA. JUNE 20, 1982 – JUNE 21 2002. WHO DIED ON THE DAY WE MET.
I KNEW WE WOULD BE TOGETHER. THEN 2 ½ YEARS LATER SOMEONE DESTROYED THAT DREAM.
THAT PERSON HAS PAID FOR THAT. THAT'S WHY I'M HERE WRITING THIS NOW.
I'LL BE WITH YOU SHORTLY THEN WE'LL BE TOGETHER FOREVER IN THE KINGDOM OF HEAVEN.
I LOVE YOU REGINA.
I STARTED THIS SENTENCE ON NOVEMBER 28, 2002, AND IT WILL END WHEN I AM PUT TO SLEEP BY THE COMMONWEALTH.

YO, C.O., C.O., I GOTTA' GO,
I SPENT ALL MY FUCKING FLOW,
I BOUGHT A LAWYER WHO DIDN'T SHOW,
AND MY STATE BIT I SURELY OWE...
C.O., C.O., LET ME THE FUCK GO.

FIVE TO TEN.
TWO AND A HALF DOWN.
MY BED IS IN MOTION.

9 – 24 MONTHS AIN'T SHIT DOG.

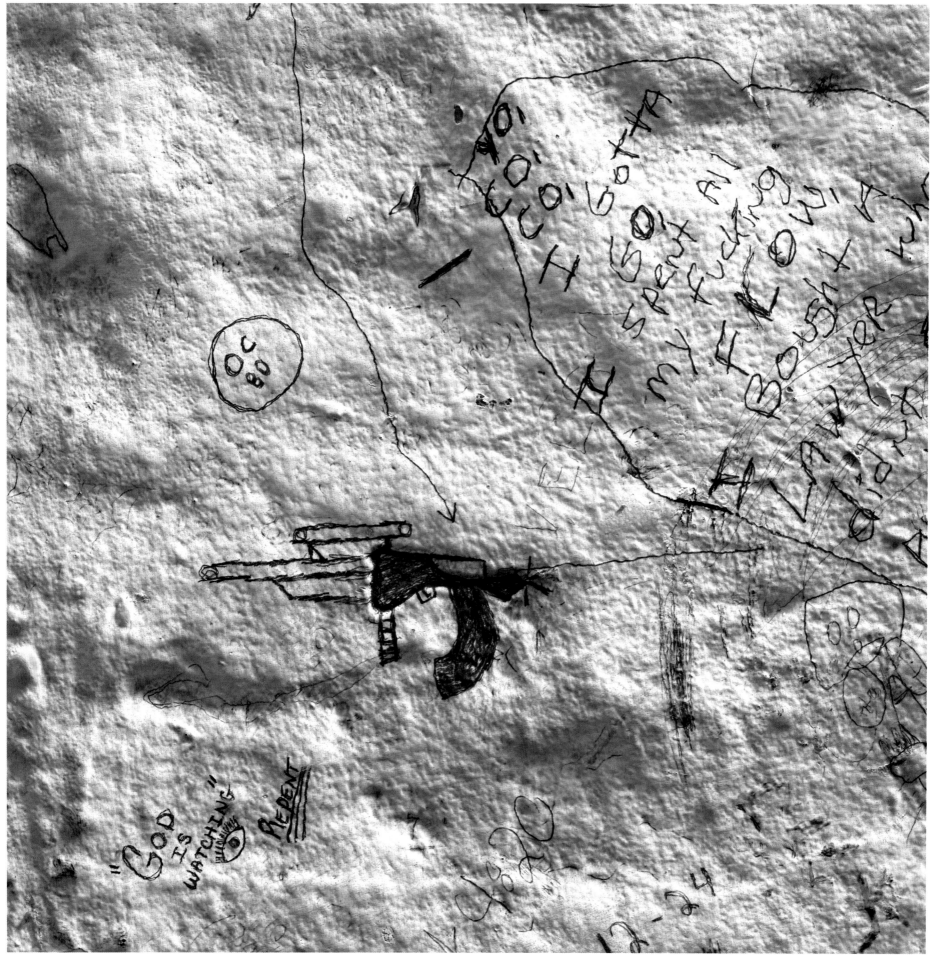

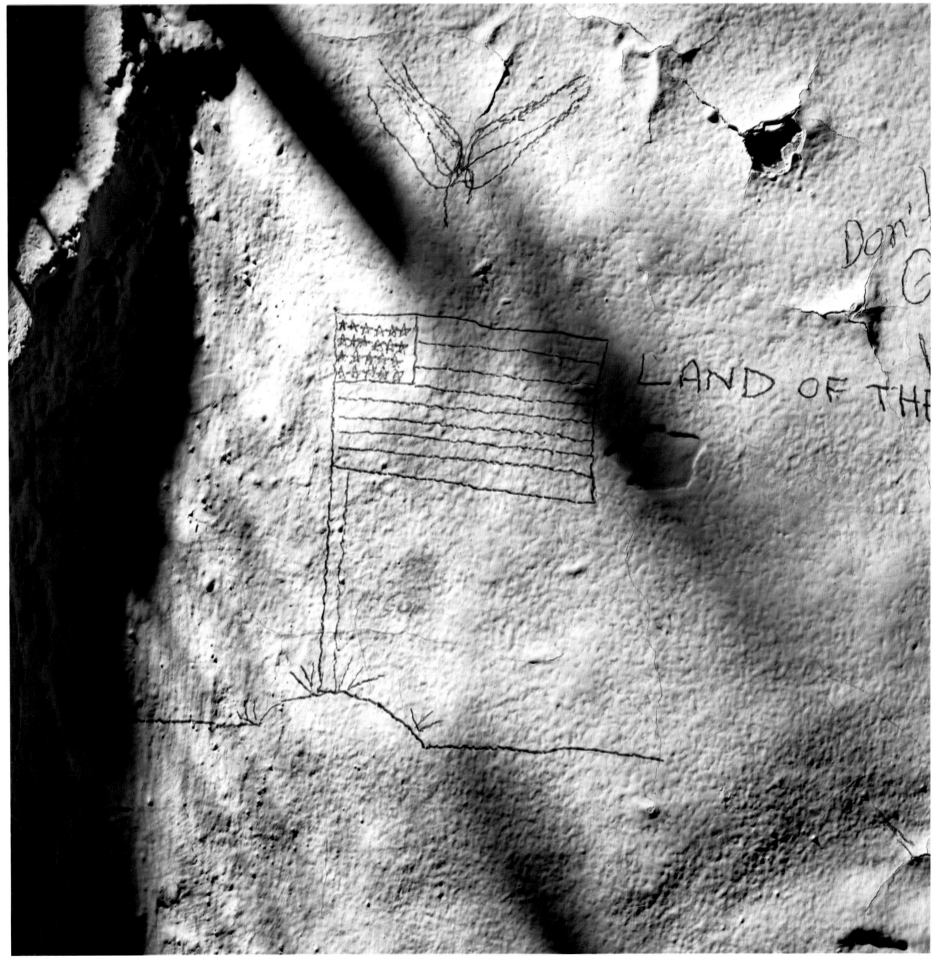

FLAG, 2005

YI YO PUERTO RICO #1
NETA GREENVILLE, PA.-03.
LA VIDA SORPRESA.
PALANTE COMO ELEFANTE.

BE SMART STAY OUT
OF HERE.

THE GUARD IS COMING
AND I'M SMOKING WEED
SO LOOKOUT BUTT THE
JOINT COMES WITH SPEED.

1–3 ALL FOR GROWING
A MARIJUANA TREE
AND THIS MAKES ME A
MENACE TO SOCIETY?
BUT HAVE NO PITY FOR
ME I'LL BE HARVESTING
AGAIN REAL SOON,
YOU'LL SEE.
GREEN THUMB DECEMBER 03

MARK MUSKIE MAN
OIL CITY PA. ALLEGHENY
RIVER. BIGGEST ONE 53
INCHES. WHAT A FIGHT.

YOUNGSTOWN. OHIO.
SOUTHSIDE 5–10 YEARS
CHARGED TO THE GAME.
4-95

GOD WILL CARRY ME,
MY WINGS ARE BROKE.

THIS IS AMERICA,
USE ENGLISH.

SWASTIKA RULE
THIS PLACE.

ONCE THEY GOT YOU
LOCKED UP THEY GOT
YOU TRAPPED. YOUR
BETTER OFF GETTING
SHOT UP.

Burn this fuckin flag.
Fuck P.R. USA USA USA
USA No.1. Try to burn this
flag asshole. I'll kill you.
Bean eating ass holes.

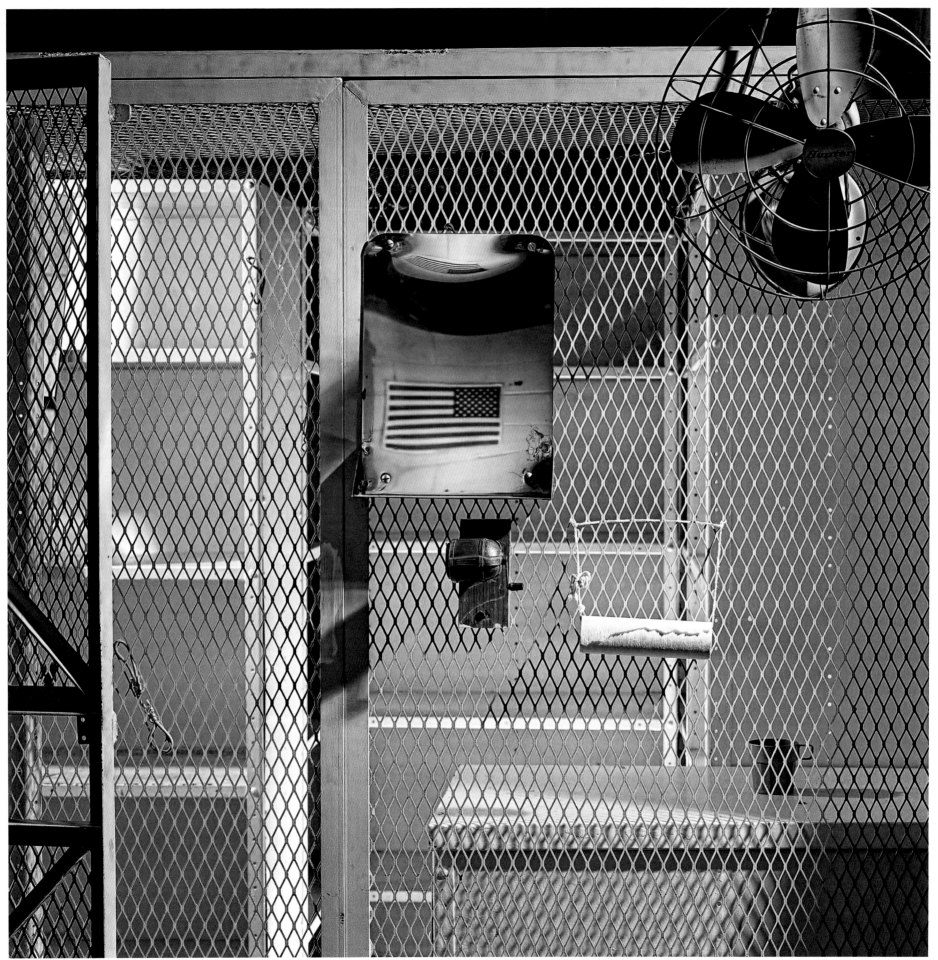

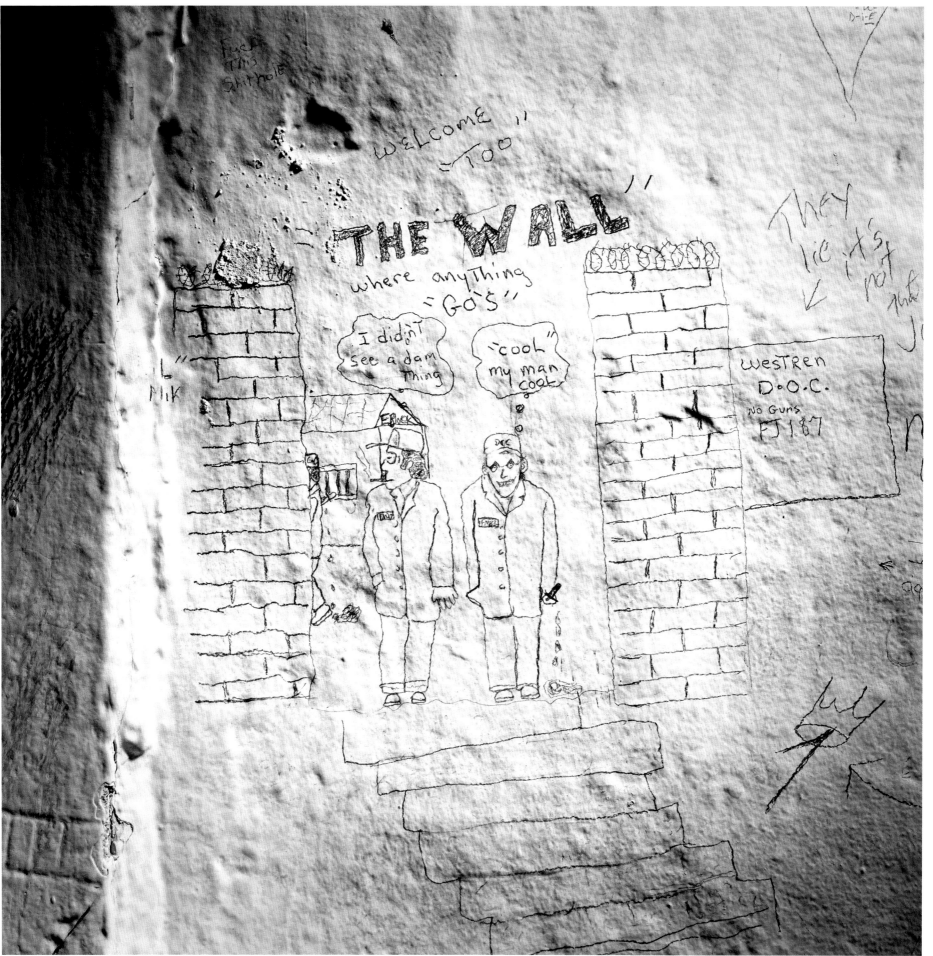

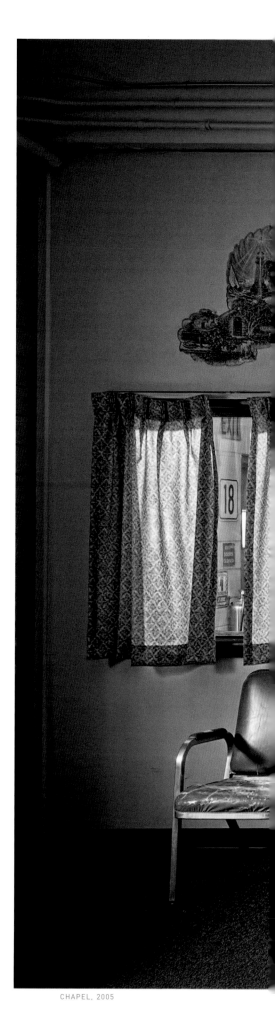

CHAPEL, 2005

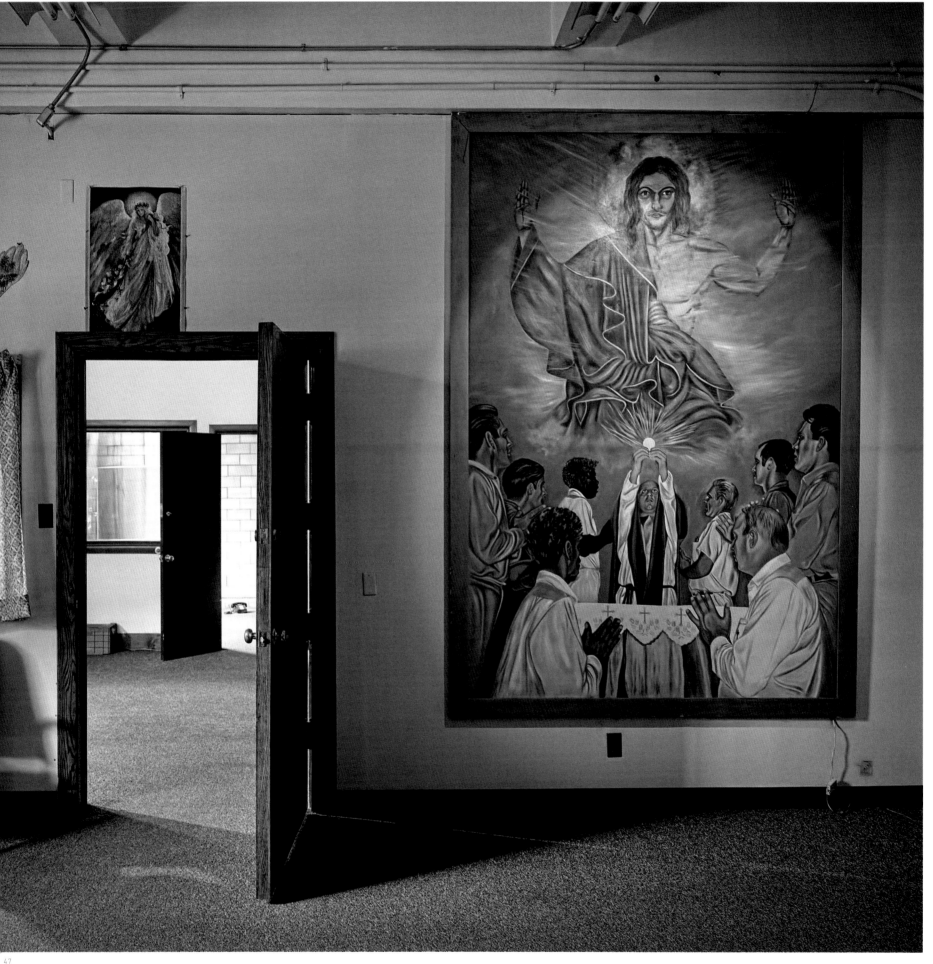

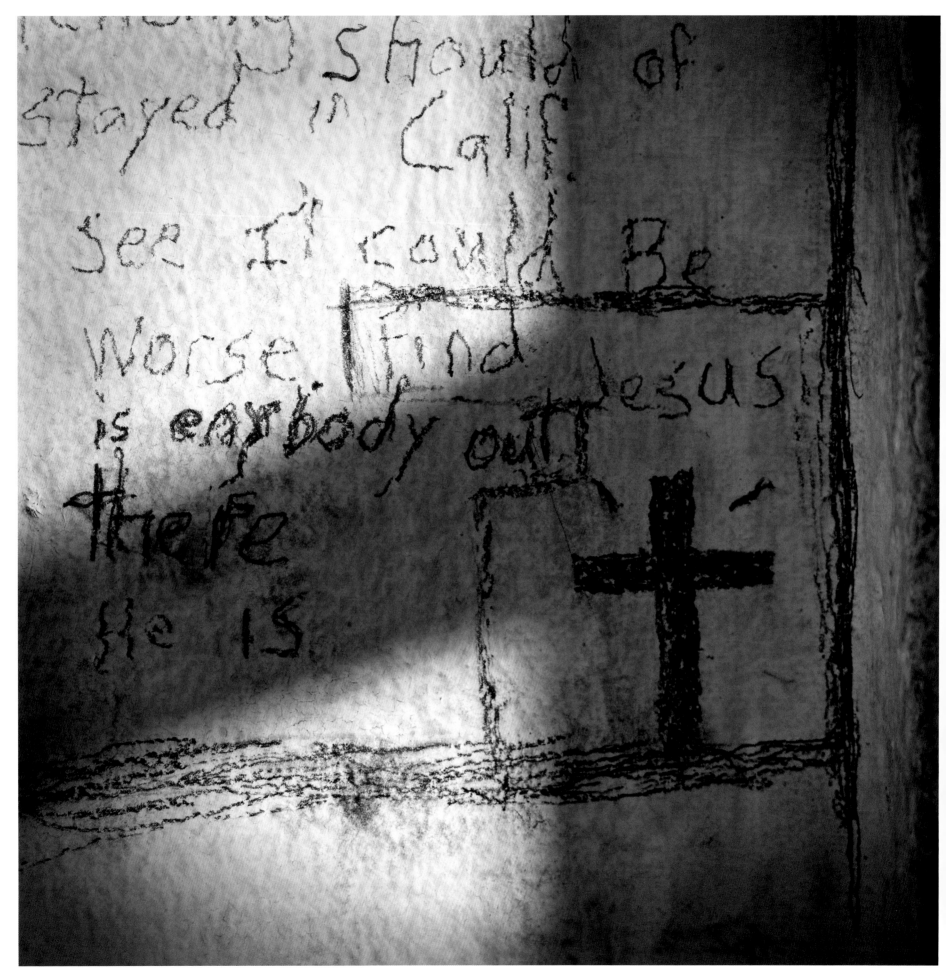

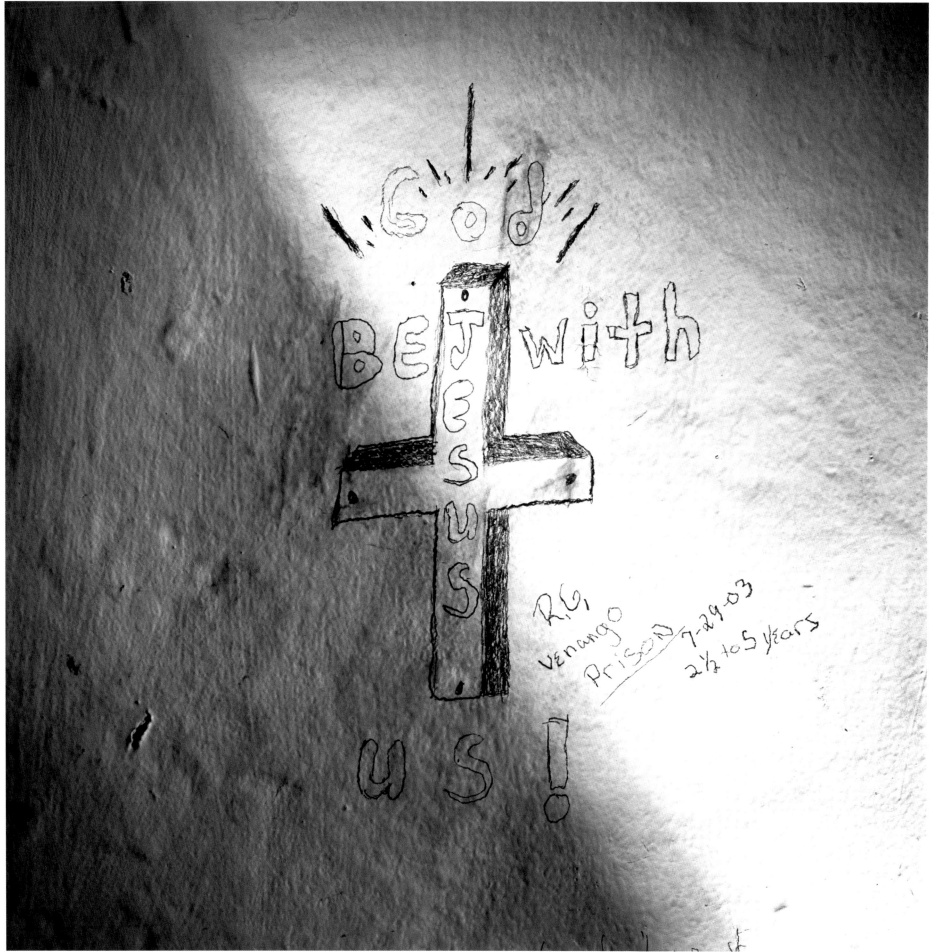

HEY CHURCHIES !!

Nothing is quite as rediculous as a man who walks the streets as some sort of tough guy - then comes to jail playing like he is religious, talking silly nonsense that inside, he knows he doesn't believe! Be silent. Rest your tongue. TAKE A NAP!

In short, don't give the man next to you a headache, subjecting him to listen to your own hypocracy! You are not smart!! RAY 10-01-03

Shut up!! Nobody cares.

Roses are red
...In in
...with

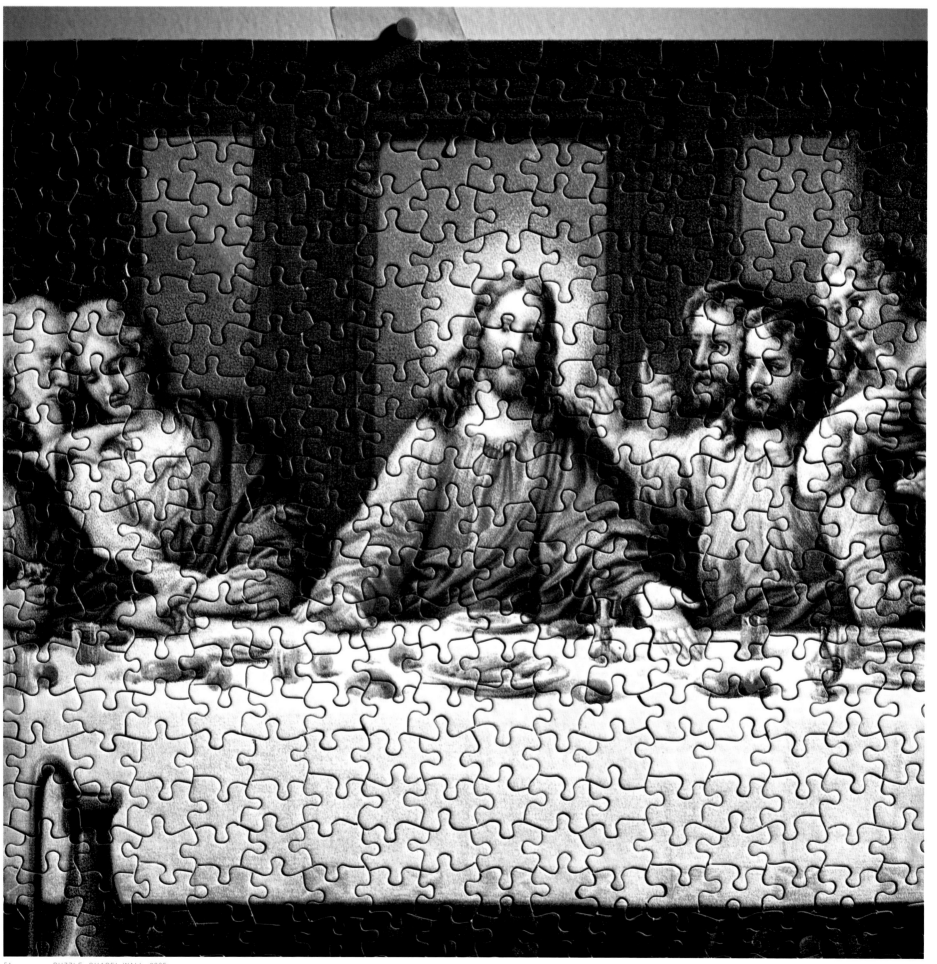

PUZZLE, CHAPEL WALL, 2005

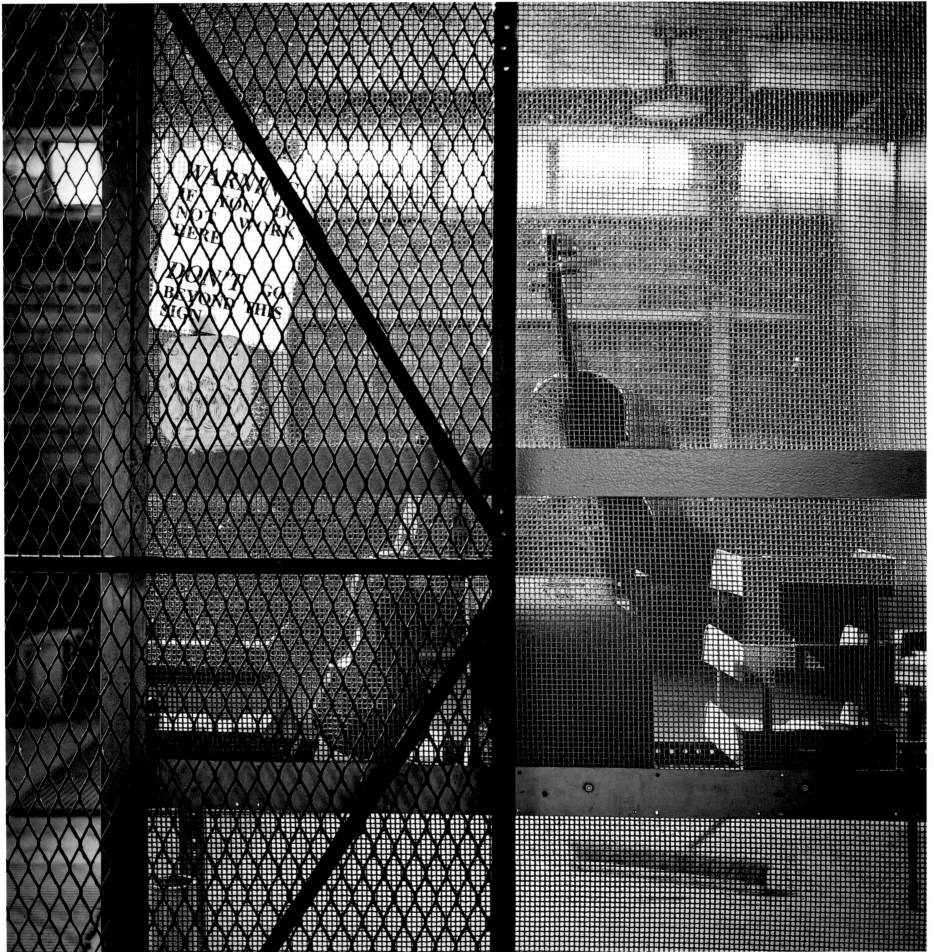

WARNING
IF YOU DO
NOT WORK
HERE

DON'T GO
BEYOND THIS
SIGN

There's only one way
to keep a secret between
three people, and that's
to kill two of them.

I be loaded in the
Range Rover/maybe
I can get a Range Rover
if I keep my ass sober/
I be loaded in the
condo/maybe I can
get a condo if I keep
my nose closed.

My father sed, always
look a man in the eye
before you kill–em.
NORTHSIDE

LOOK UNDER THE DESK.
THERE WEED.
HERE SMOKE IT, BEFORE YOUR PISS TEST.

IF YOU WANT TO GET OUT, TAKE YOUR SHEET, TIE A KNOT
IN IT, WRAP IT AROUND YOUR NECK, PUT IT IN THE BAR
UP AT THE DOOR. HANG YOUR SELF.

MY MOTHER ALWAYS SAID...IT TAKES A BETTER MAN
TO WALK AWAY. NOW I SIT HERE AND PONDER OVER THIS
20 YR. BIT.

ITS HOTTER IN THE SUMMERS. COLDER IN THE WINTERS,
WHEN THE BOARD PAROLES YOU THEN ANOTHER CON
ENTERS.

5 TO GO ON A 20 YEAR BID, SO STOP CRYING SMALL TIMER!
(BIG SING)

I DON'T FEEL THE SUN COMING OUT TODAY. ITS STAYIN
IN. ITS GONNA FIND ANOTHER WAY. AS I SIT HERE IN THIS
MISERY I DON'T THINK I'LL EVER SEE THE SUN FROM HERE.

IF GOD LOVES US, WHY DID HE LET ME DO WHAT I DID
TO HER? AT LEAST SHE CRIES NO MORE.

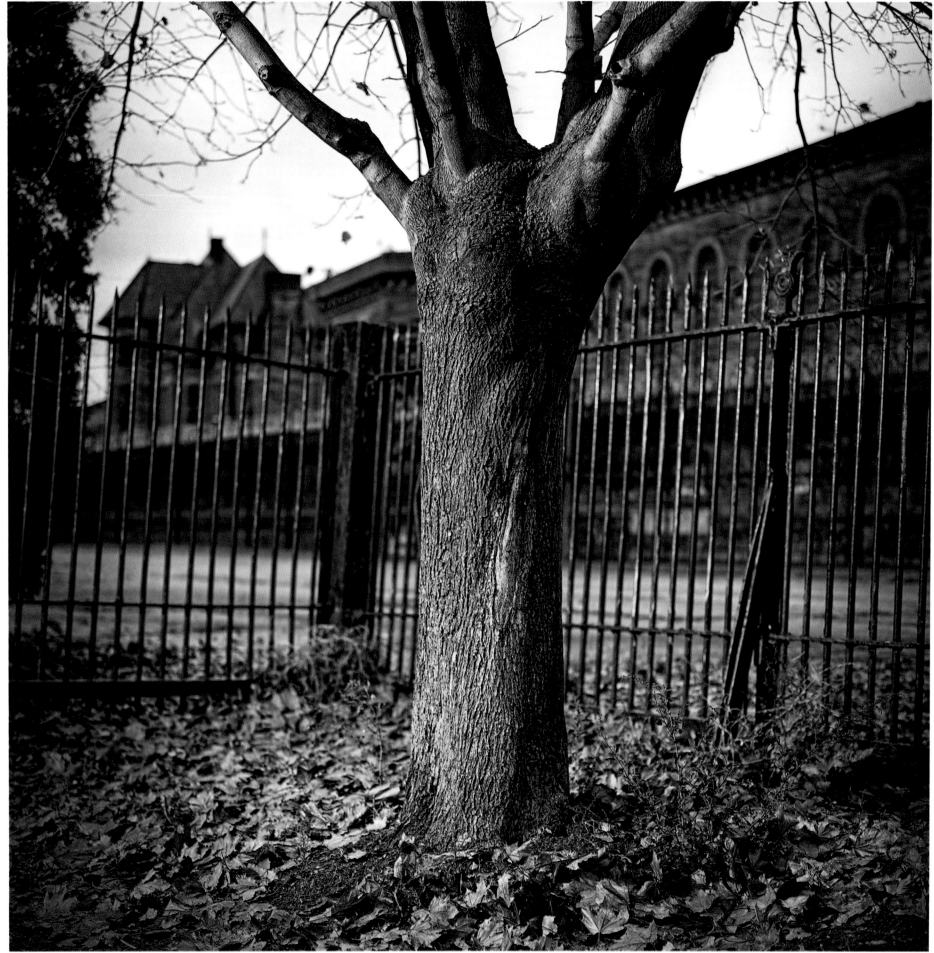

TREE, 2006

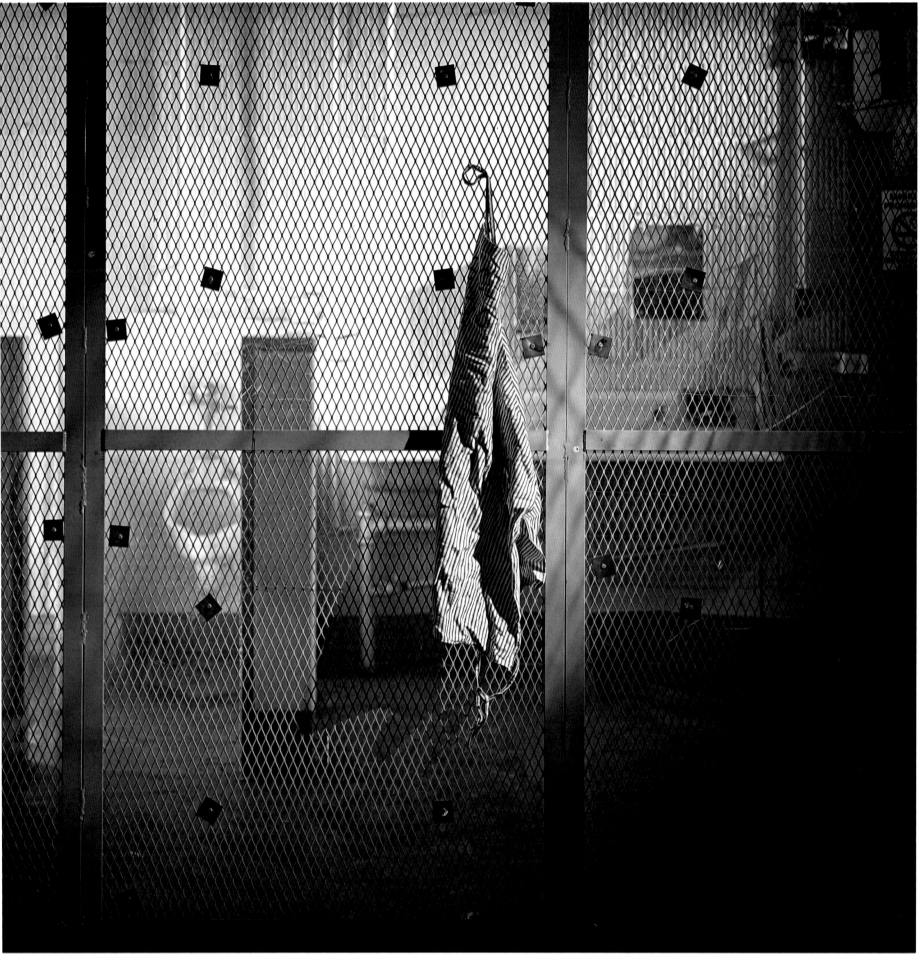

152

WE DON'T LIKE
(SCRATCHED OUT NIGGERS)
WE HANG THEM HIGH
FROM THE GREAT RED OAK
DOWN TO THE VIRGINIA
WHITE PINE. WE DON'T
WEAR GOLD CHAINS, PUT
OUR PANTS ON A LITTLE
TOO TIGHT, BUT WE KNOW
HOW TO HANG 'EM COME
SATURDAY NIGHT.

THIS CELL IS TOO SMALL.

NORTH CAROLINA WAS
HERE, THANKS TO ERIE.
STAY OUT OF ERIE, PA.
5-12-03

DON'T SHED A TEAR
'CAUSE MOMMA I AIN'T
HAPPY HERE. I BLEW TRIAL,
NO MORE SMILEZ FOR A
COUPLE A YEARS.

VOICES, SO! WAKE UP!
ARE YOU ALIVE?
LISTEN TO ME. I'M GOING
TO TALK ABOUT SOME
FREAKY SHIT NOW.
SOMEONE IS GOING TO DIE
WHEN YOU LISTEN TO ME.
LET THE LIVING DIE.
LET THE LIVING DIE.
ARE YOU BREATHING NOW?
DO THE WICKED SEE YOU?
ARE YOU BREATHING?
ARE YOU MAKING ME KNOWN?
YOU BREATHING NOW?
DO THE WICKED SEE YOU?
YOU STILL BREATHING?
SO! WHAT'S UP?
I WONDER WHY.
THE SICKNESS.

DO YOU SELF A HUGE FAVOR.
GET THE FUCK OUT OF P.A.!
GO SOUTH!

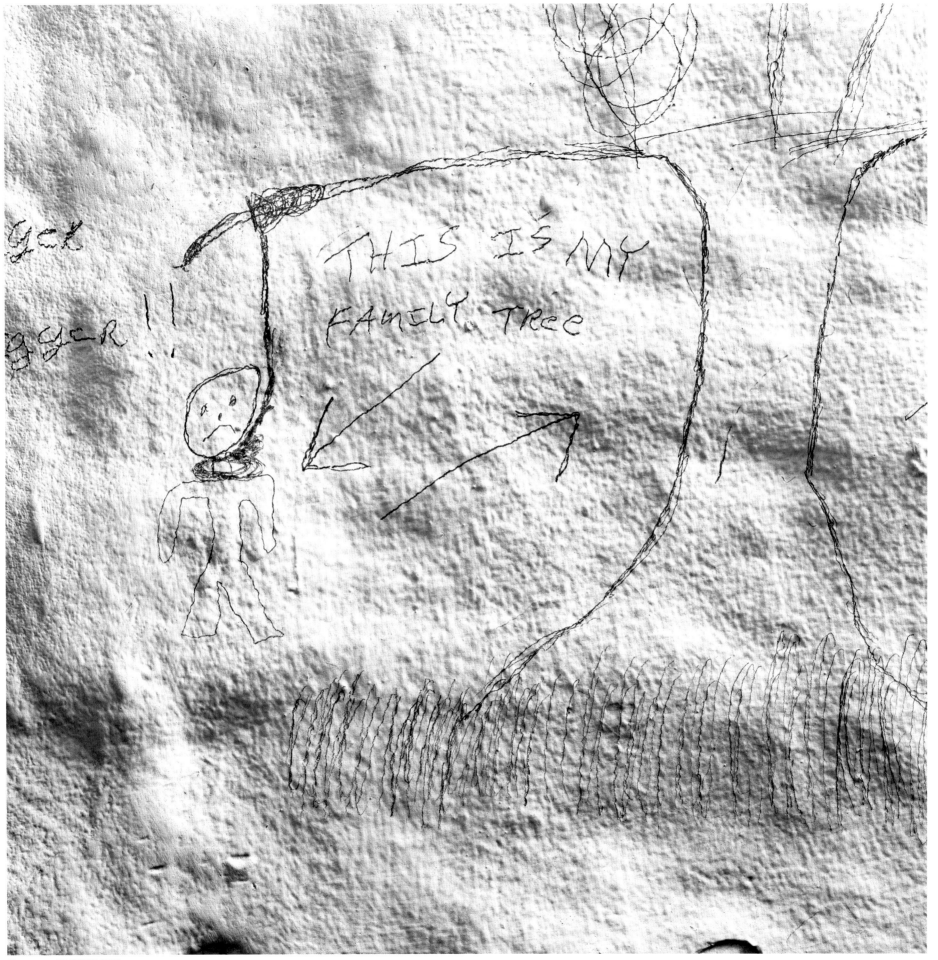

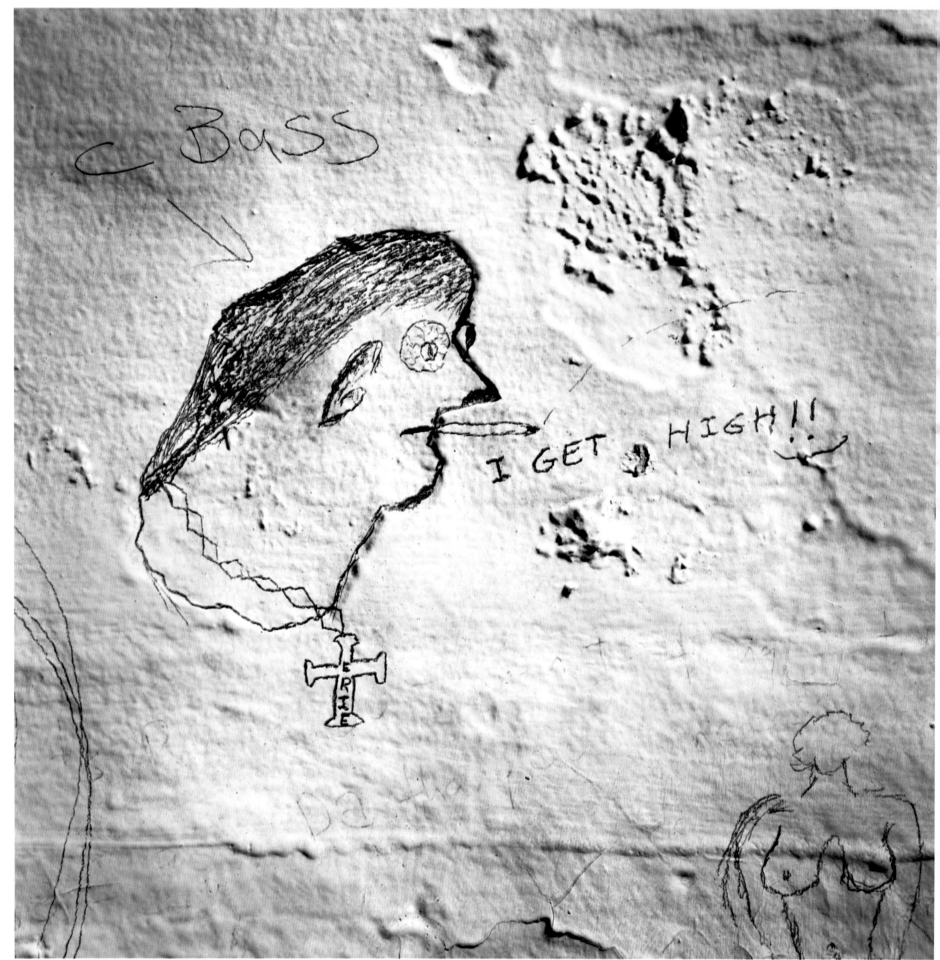

SLIM JIM 2-25-04 WAS HERE FOR THE LAST TIME.
ONCE YOU FIND HIM YOU HAVE TO KNOW WHAT TO DO WITH HIM!

LOOK ON THE BRIGHT SIDE — SUICIDE.

IT'S ALL ABOUT THE NEEDLE AND THE SPOON,
TAKE A TRIP TO THE MOON, IT TAKES YOU AWAY.

MOST ERIE DUDES ARE FAGGOTTS AND SNITCHES THAT
MAY BE POSSIBLE. LOOK OUT FOR THE ONES THAT AREN'T,
AND READ YOUR NOTES.

KINDNESS IS A LANGUAGE THAT DUMB CAN SPEAK,
DEAF CAN UNDERSTAND.

WITHOUT DARKNESS WHICH ONLY LIGHT BRINGS
HALF WOULD BE LOST INCLUDING OUR DREAMS.

WE DID 19 ½ YEARS GOT OUT FOR 1 ½ YEARS. WENT BACK AS
P.V. WITH A S.A. CHARGE. DON'T KNOW HOW MANY MORE I WILL
DO THIS TIME. BEEN THERE DONE THAT OVER AND OVER AGAIN.

I WOULD LIKE TO THANK THE U.S. NAVY FOR SHIPPING ME
AROUND THE WORLD (THRICE) SO I COULD VISIT STRANGE LANDS,
MEET EXOTIC PEOPLE, STUDY DIFFERENT CULTURES,
TRAIN AND PARTY WITH NATIVE ARMIES,
AND MOST IMPORTANT— CRUSH FOREIGN PUSSY.

BLOCK THE DEVIL'S WHISPERS.

WAR OF LIFE.
DO THE CRIME.
PAY THE PRICE.
HOPING GOD FORGIVES.

TO SNORT COCAINE. TO ACT INSANE.

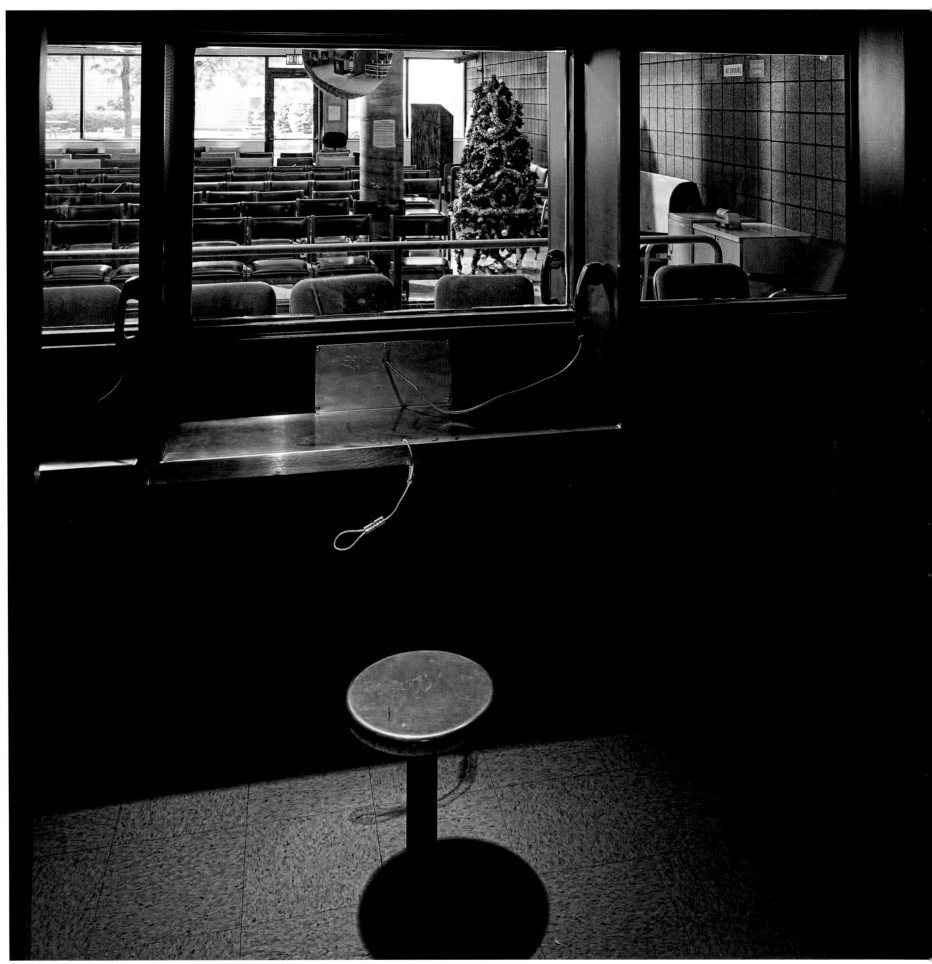

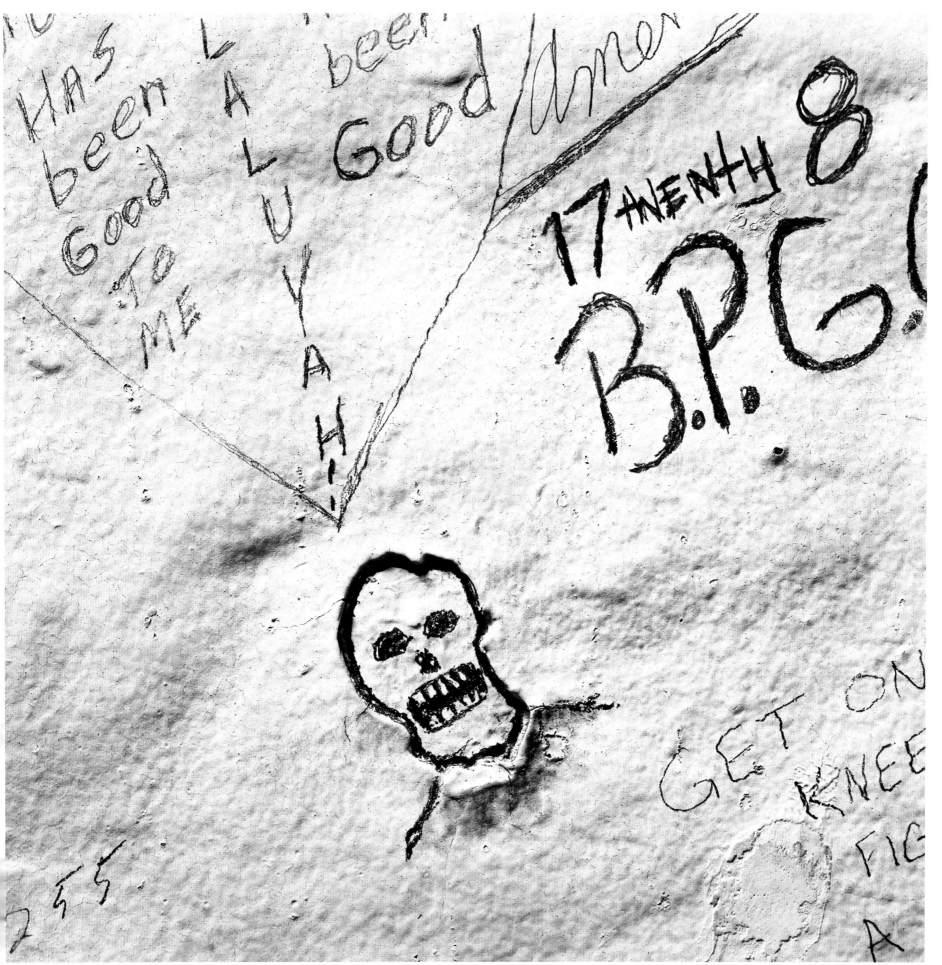

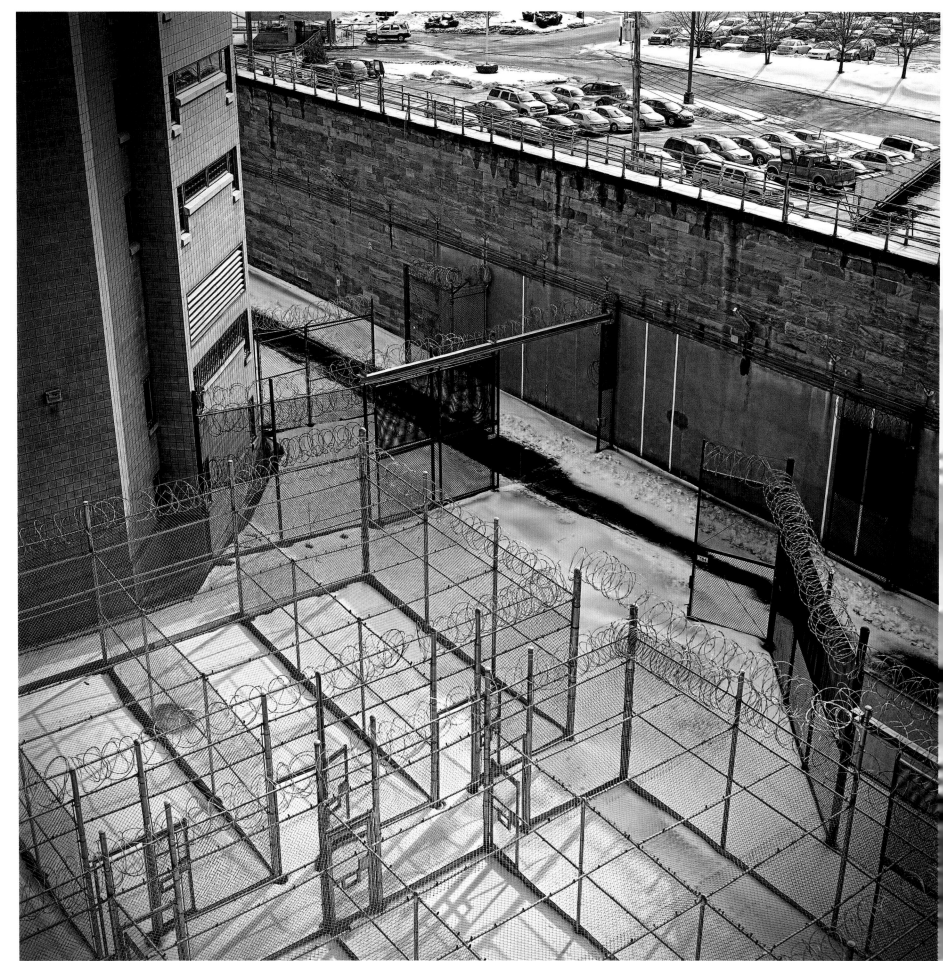

Showers
Monday
Wednesday
Friday

1 yard a day

Commissary – Friday

Monday
Wednesday
Friday
bus leaves for
Camp Hill

Football on Sunday
– no yard

Laundry day – Friday

Lose one towel,
sheets

**Library
one time a month**

DON'T SWEAT IT. YOU WILL LEAVE THE JAIL SYSTEM SOONER OR LATER. EITHER YOU WILL, LEAVE ON YOUR OWN, OR THEY WILL CARRY YOUR ASS OUT IN A BODY BAG. YOU MAKE THE CHOICE.

I LAID HERE AND JACKED OFF SO MANY TIMES IT FEELS SO GOOD. MY SHIT HURTS. USE THE BUTTER.

YO, DIG THIS RIGHT. WHEN YOU HIT DEM STREETS KEEP TO YOURSELF, DON'T FUCK WITH THEM NIGGAS YOU FUCKED WITH BEFORE. DO WHAT YOU DO TO GET THAT $ BUT STAY OFF THEM DRUGS. THAT SHIT ONLY GETS IN THE WAY. I'M TELLING YOU THEM STREETS AIN'T SWEET NO MORE. LOTS OF LUCK TO YA.

READ. "TED M. IS A FUCKING RAT FROM BUTLER, PA." WATCH OUT!!! MAKE HIS ASS PAY. IF HE EVER WALKS THRU THESE DOORS MAKE SURE HE LEAVES FEET FIRST.

PEOPLE AREN'T EXPENDABLE, GOVERNMENT IS. TO ALL THE KIDS FROM THE GUTTERS, THE GRAFF HEADS, THE STREET KIDS, THE SQUATTERS, THE TRAMPS, AND THE PUNX, KEEP YOUR HEAD TIGHT. FIGHT THE GOOD FIGHT. DOESN'T MATTER THE COLOR OF YOUR SKIN, OR IF YOU'RE GAY OR IF YOU'RE STRAIGHT, YOU'RE HUMAN, WE'RE KIN. REMEMBER ALEXANDER BERKMAN, WHOM SERVED FOURTEEN YEARS HERE IN THE LATE EIGHTEEN HUNDREDS FOR SHOOTING THAT ASSHOLE HENRY FRICK. HE WROTE A BEAUTIFUL BOOK INSIDE THIS WALL TITLED "PRISON — MEMOIRS OF AN ANARCHIST." IF YOU EVER GET THE TIME TRY TO GET IT. STAY HEADSTRONG, KEEP ON KEEPIN' ON!

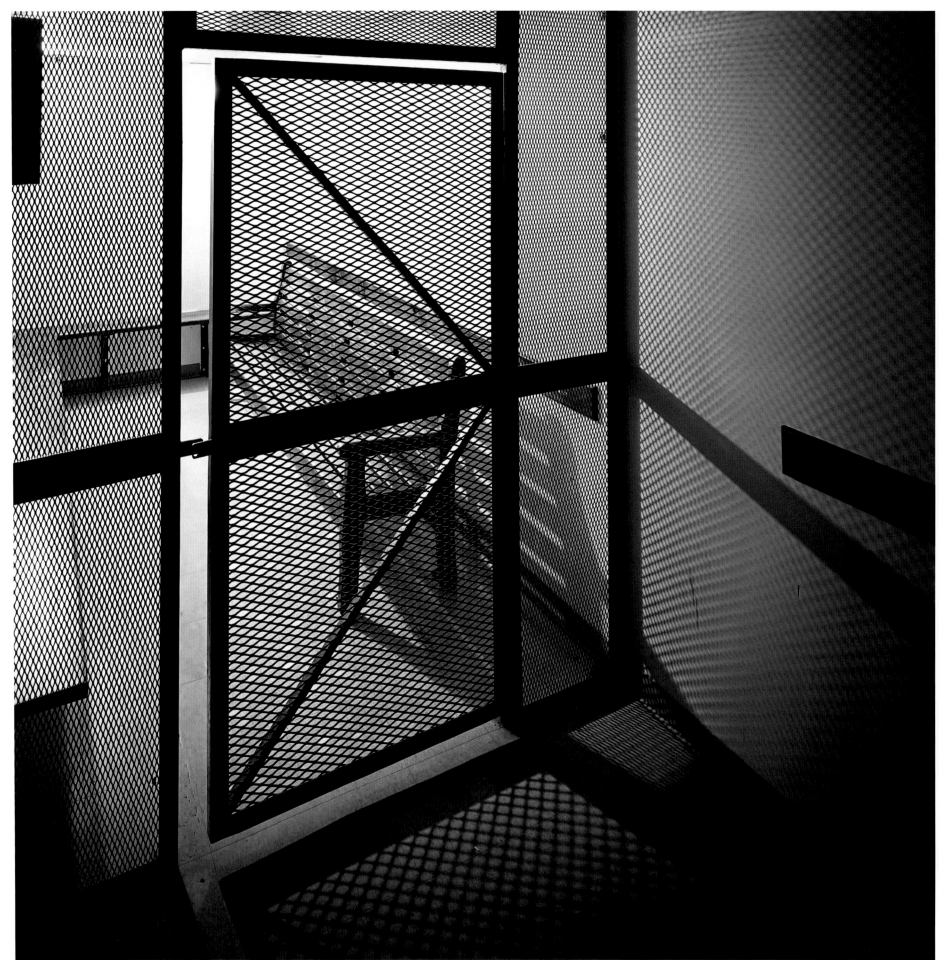

BENCH, HOLDING PEN

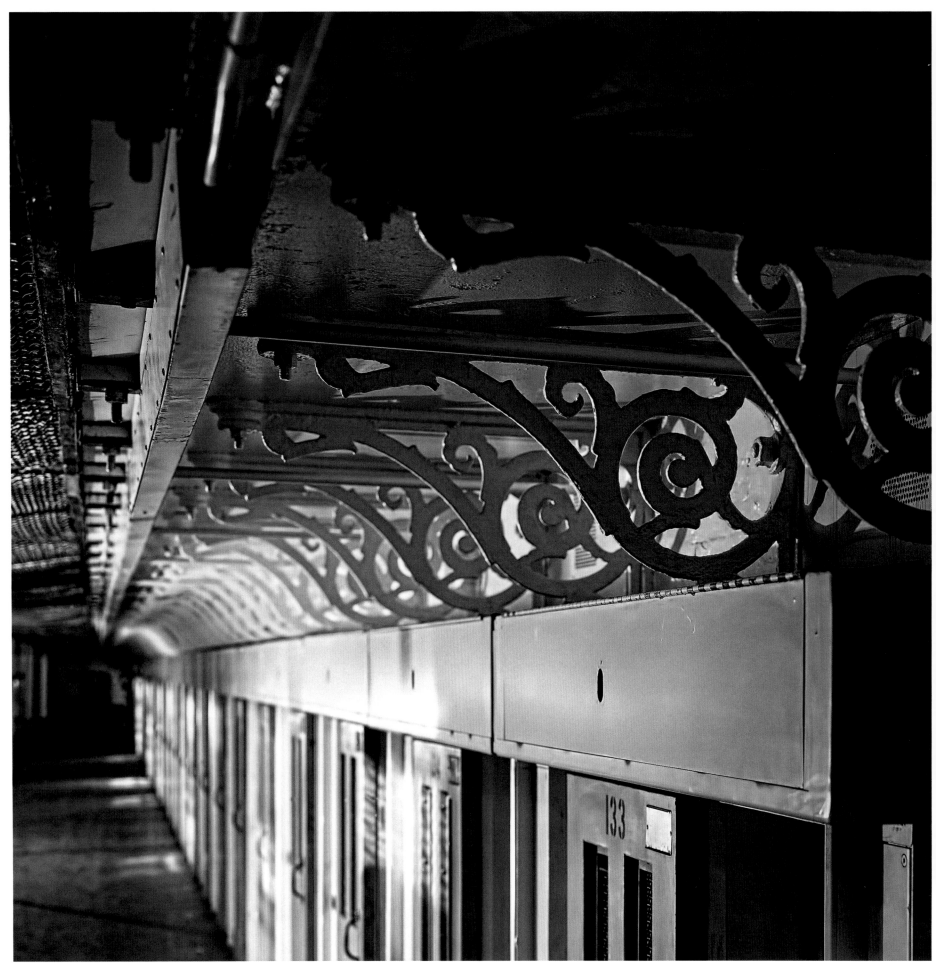

WHISKEY MAN DID
THE CRIME & I'M DOIN
THE TIME. I GOT 1½
TO 3 PLUS 20 YEARS
PROBATION!!!

CYANIDE IS THE
ACTIVE INGREDIENT
IN RAT *POISON*.
IT IS ALSO FOUND
IN CIGARETTES.
INFECT THE TRUTH.

IN TEN YEARS
100 MILLION PEOPLE
WILL DIE FROM AIDS .
100,000,000 PEOPLE!
WRAP IT UP!
SAFE SEX!

EXTACY, COKE,
SOME SAY IT'S LOVE
BUT IT'S *POISON*.
PHYSICIANS
PROSCRIBING US
MEDICINE IS *POISON*.
**LACK OF EDUCATION
FOR GHETTO KIDS.
THAT'S POISON.**

STILL DELIVER
THE ORDER
MAN.
I AIN'T TALKING ABOUT
CHICKEN AND GRAVY
MAN.
I'M TALKIN' ABOUT
BRICKS AND HALVES.
HALVES AND QUARTERS.
4½ NOW WRAP,
YOU DO THE MATH.
HEAT ON BLAST
'TILL MY STACKS
IN ORDER
MAN.

**TO BE SEEN — STAND UP,
TO BE HEARD — SHOUT OUT.
TO BE APPRECIATED — SHUT THE FUCK UP.**

ONE BURGLARY GOT ME HERE AND
ONE MAN WILL GET ME OUT.

WE CAME HERE BY OURSELFS WE'LL LEAVE
WITH OUR HEADS HIGH. AND GRACE FULL.

DRG

STAND UP.
WHEN I BANG YOU BANG.
IT'S LIKE THAT.

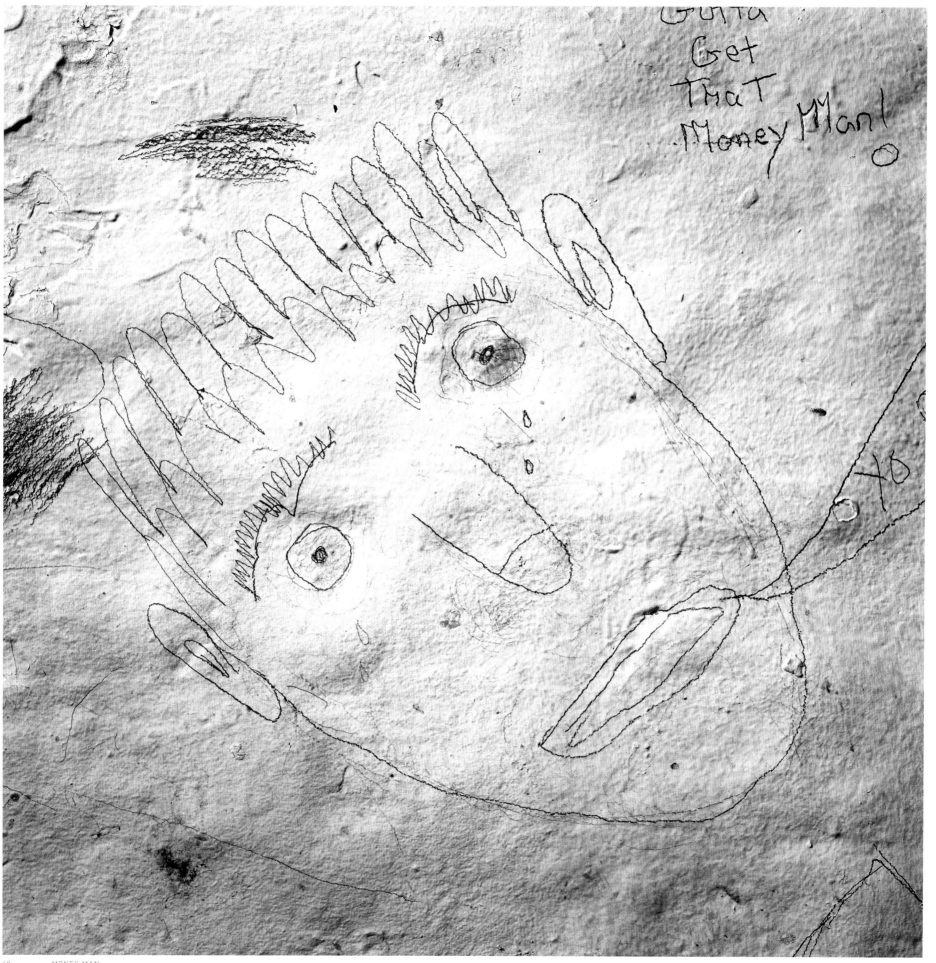

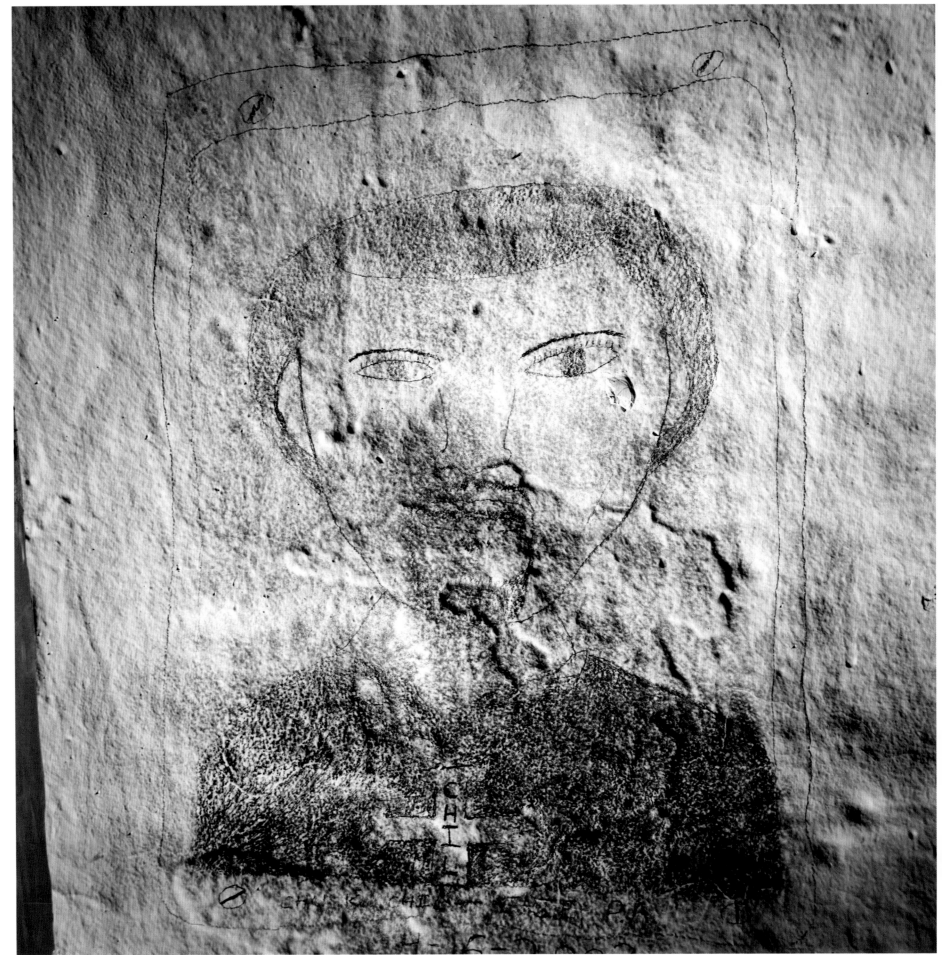

When my X-wife tells me to go to hell she wants me to improve the quality of my life.

I hope while you're sittin in this cell you know something's missing. So sit back and start working at it, so when it's time you won't be sitting here **again** reading this shit **again.**

Don't go to jail asshole.
Too late.
Look where you are now.

At / your / sister / and / I'll / tell / you / this / you / know / for / only / thirteen / she / got / som / big / tits / after / that / your / dad / would / try / to / jump / again / but / this / time / I'd / put / the / forty / to / his / chin.

TIL I BUST A CLIP IN YOUR FACE PUSSY DIS BEEF AIN'T OVER. **REVENGE** GETS YOU EVEN WITH YOUR ENE-MY, **FORGIVENESS** PUTS YOU ABOVE HIM.

YOU STARTED IT. YOU CAN STOP IT! DON'T TAKE NOTHIN. GO TO A MEETING & PRAY.

YEAH. PRAY THE DOPE MAN ANSWERS THE PHONE.

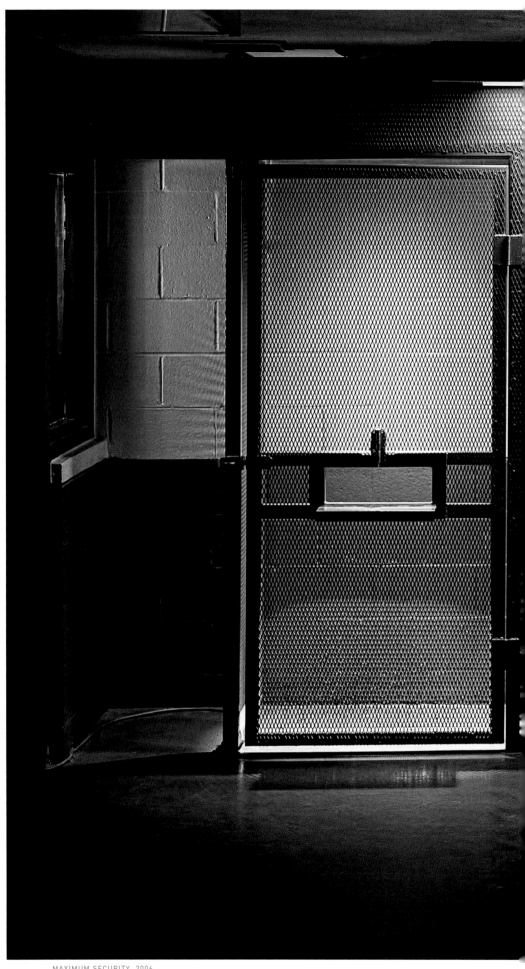

MAXIMUM SECURITY, 2006

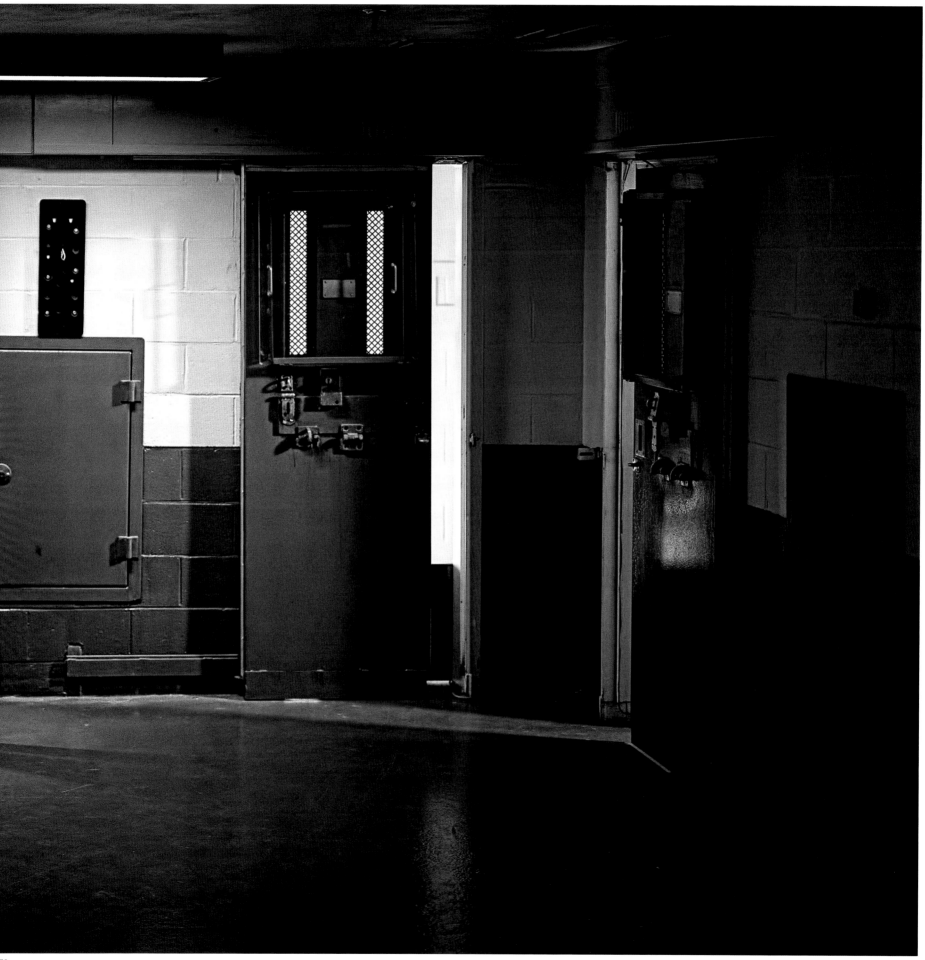

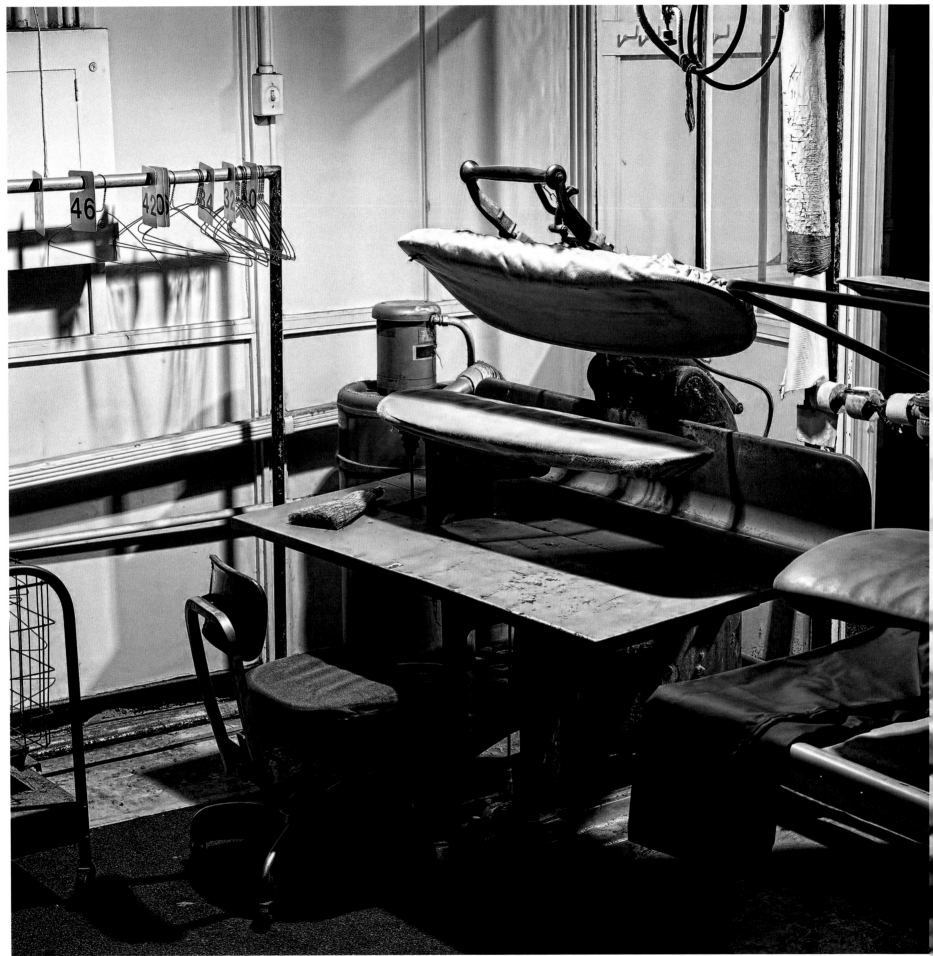

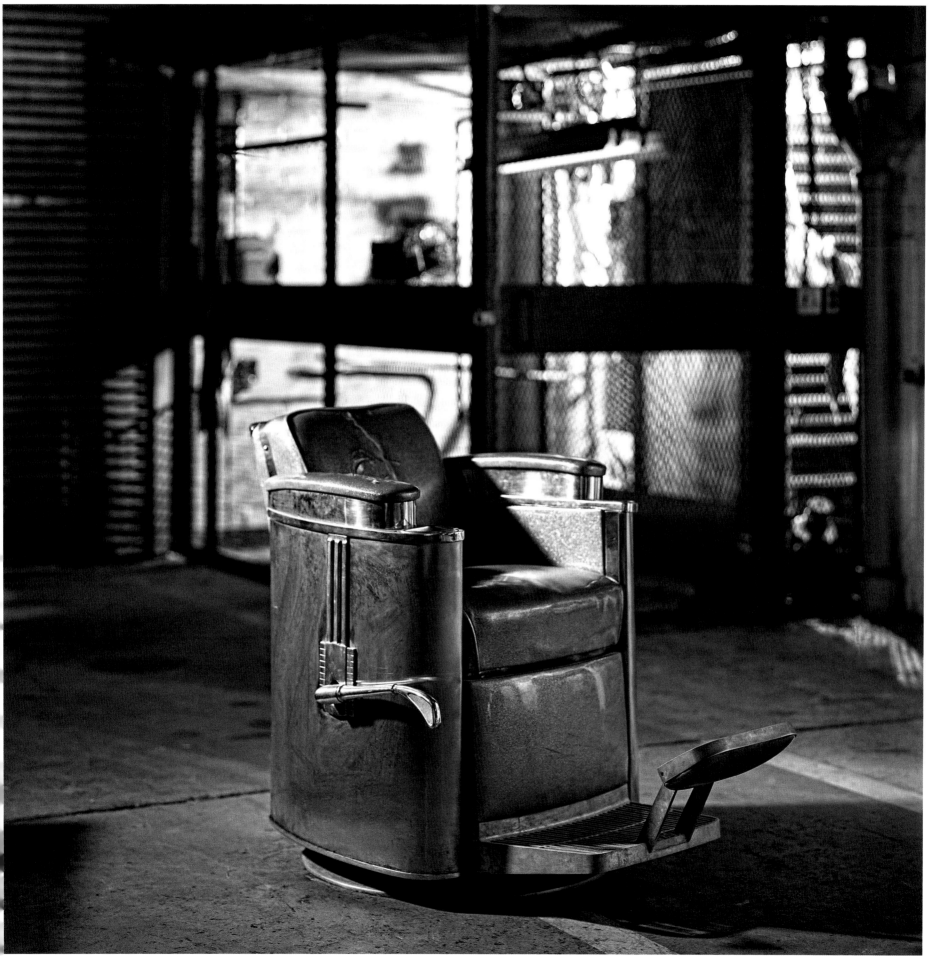

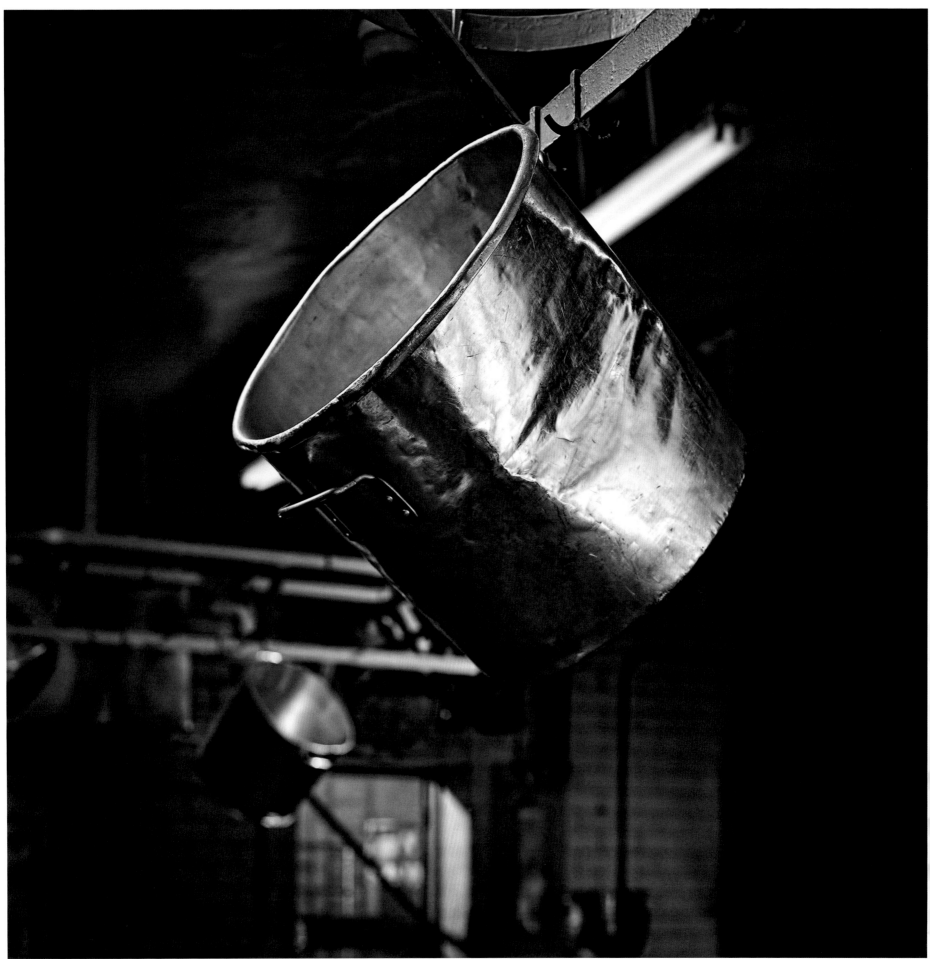

POTS, PRISON KITCHEN

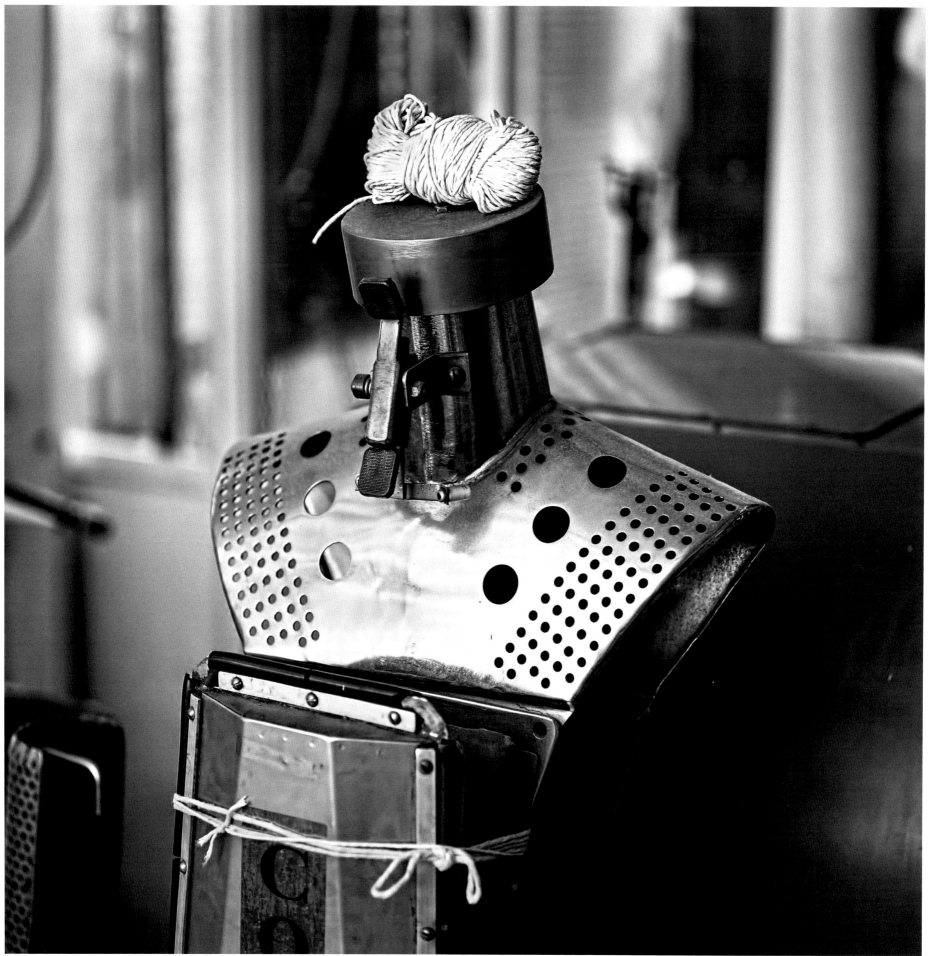

MY HEART. MY BETTER HALF. MY PARTNER SOUL MATE. WE CAN LAUGH AND JOKE TOGETHER AND HAVE A GOOD TIME. YOU SAW SOMETHING IN ME THAT I SAW IN MYSELF, THAT THE REST OF THEM BITCHES DIDN'T SEE IN ME. YOU SAW THE SWEET SIDE OF ME, AS IN THE SWEET AND SOUR MOTHERFUCKER YOU ALWAYS CALL ME **(SMILE)**. I PUT THIS ON MY LIFE THAT NO-BODY OR NOTHING WILL EVER COME BETWEEN US. I COULD NEVER LOVE NO OTHER YOU'RE THE BEST I EVER HAD.

WHEN YOU'RE ON THE STREETS AND THINGS WERE LOOK-IN GOOD YOU DECIDED TO BE A HOOD. NOW YOU'RE HERE WITH NO ONE TO CALL. SO ALL YOU CAN DO IS LOOK AT THESE WALLS. **(SO THINK ABOUT THAT)**.

I WAS HERE IN '98 AND 2004 I SURELY HOPE THERE WON'T BE ANY MORE. SO I LEAVE THIS IN HOPE FOR YOU.

WHEN YOU WERE ON THE STREET AND THINGS WERE A MESS, YOU THOUGHT THINGS COULDN'T GET ANY WORSE. TAKE A LOOK AT WHERE YOU'RE AT, ALL YOU HAVE IS THIS HOLE HARD BED.

WHO SAYS "CRIME PAYS"? 5 TO 13 YEARS LOST TO PA. **FUCK THAT.**

KIDS-O

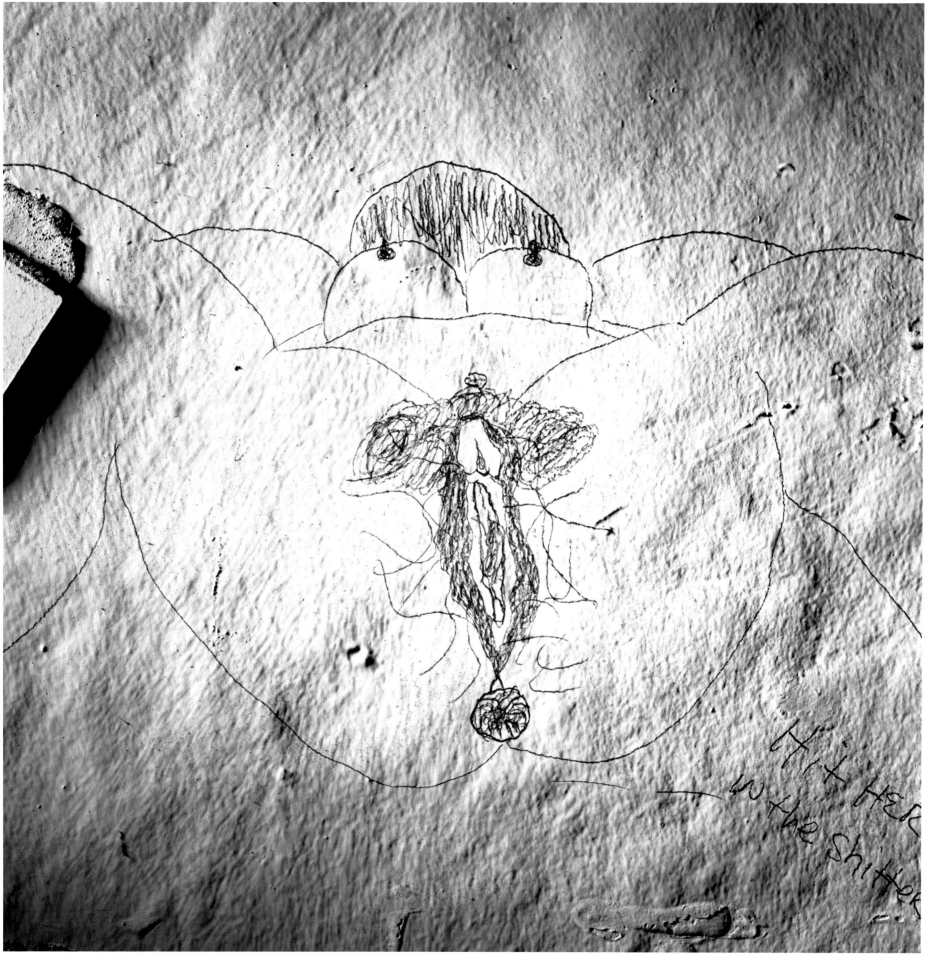

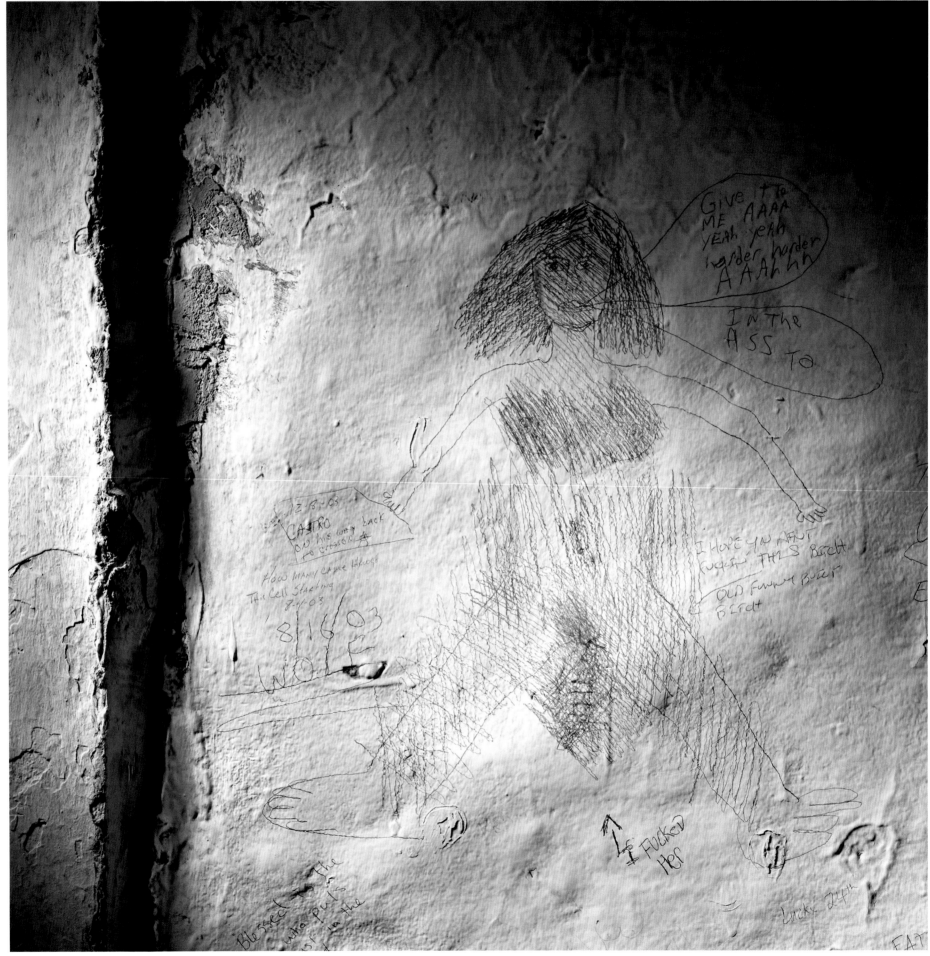

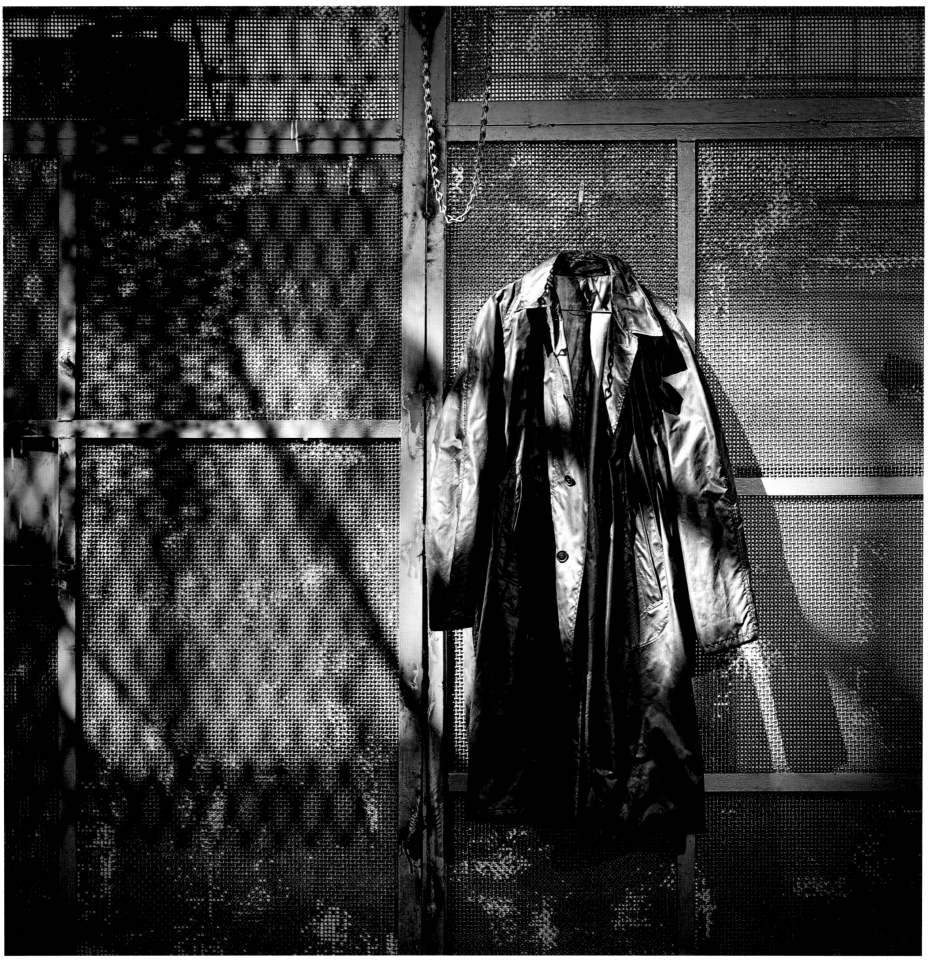

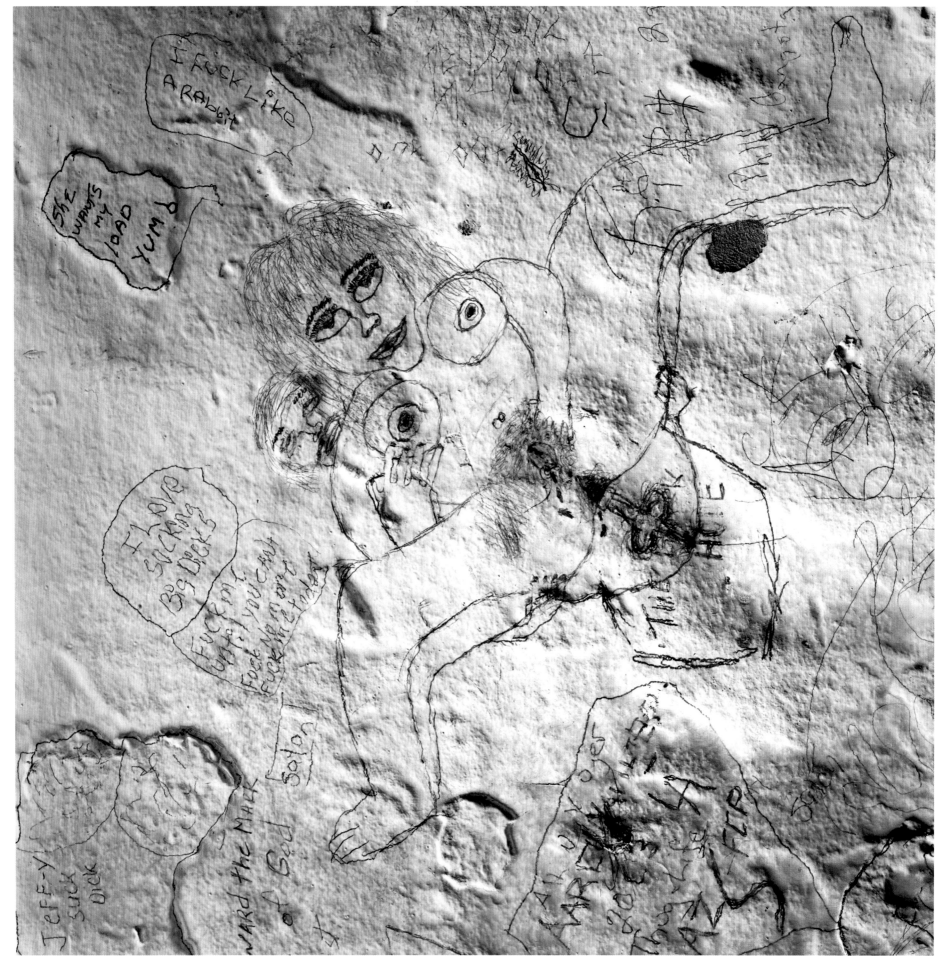

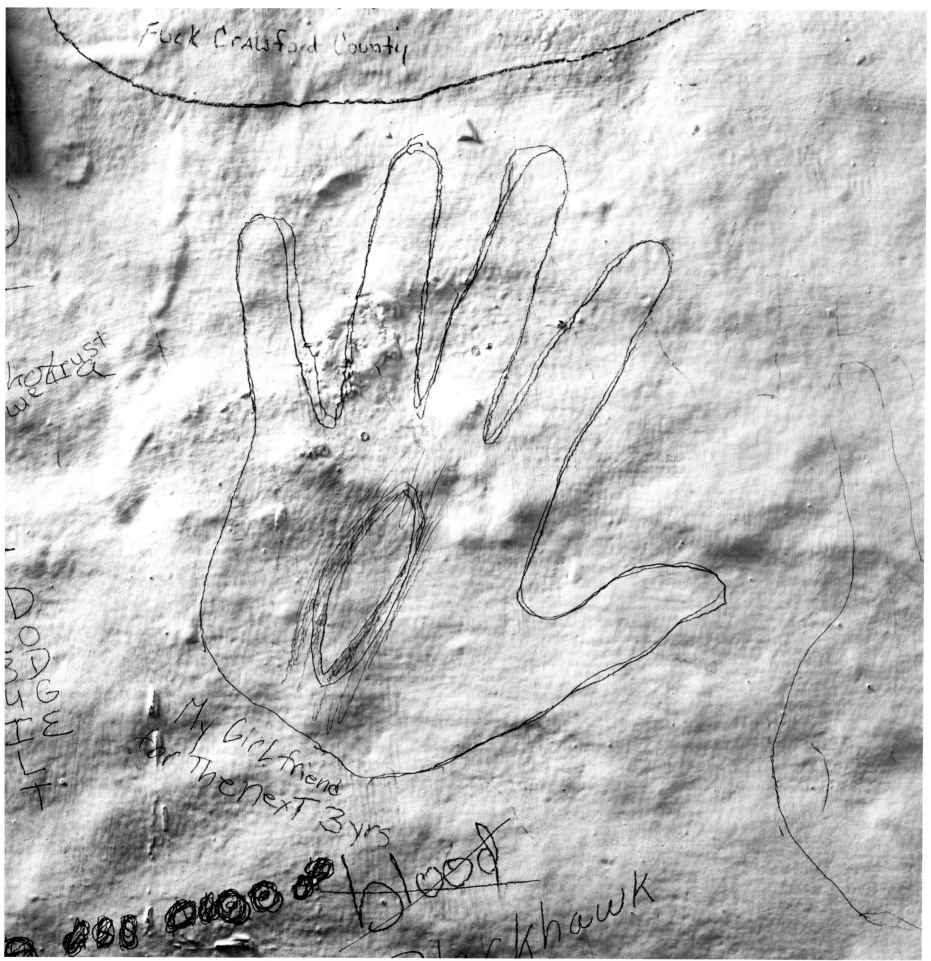

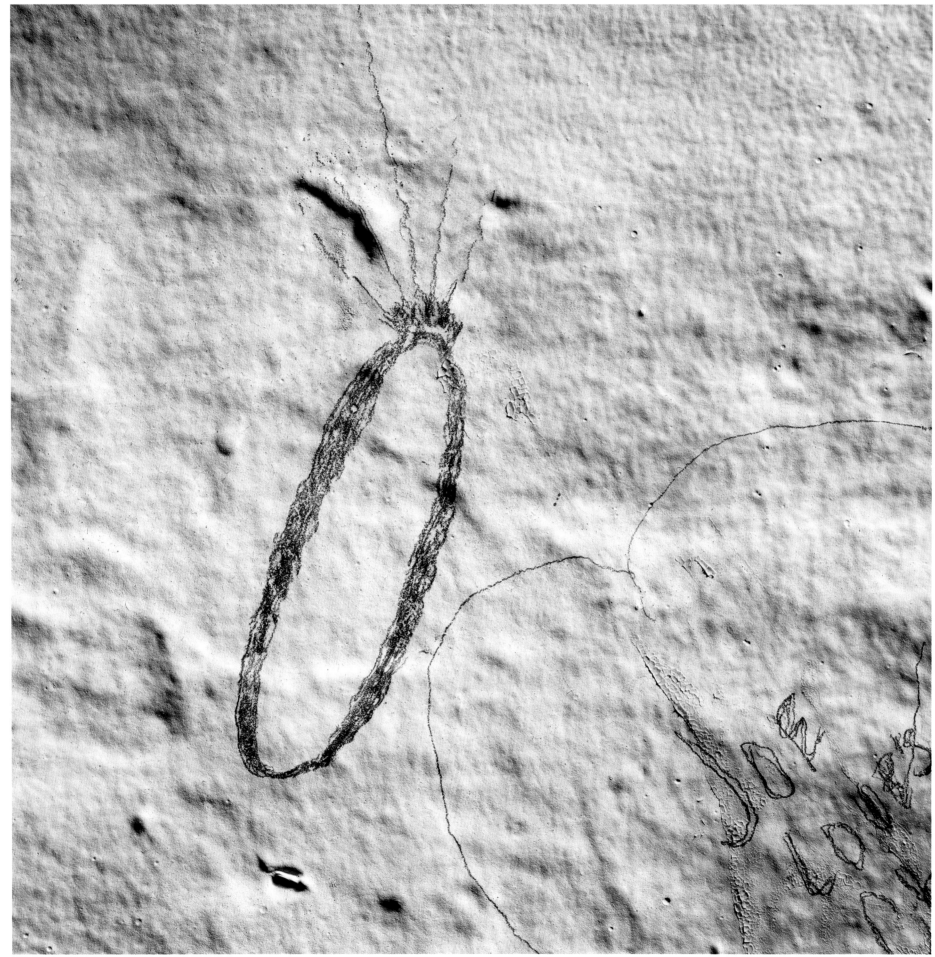

DIAMOND RING, JOE LOVES

AFTER YOU SEE THROUGH
ALL YOUR GREED AND YOUR
NEEDS, YOU WILL REALIZE
THAT YOU WHERE JUST ABOUT
AS BAD AS ME.

YA'LL YHINK 'BURG IS THE SHIT,
COME TO FALLS TOWN.
6-12 YEARS FOR ROBBERY
CO-DEFENDANT 6 MONTH FOR
SNITCHIN' ON A BEATABLE CASE.

DUI 1-5 YEARS JAMESTOWN, PA

ROSES ARE RED,
VIOLETS ARE BLUE
I'M IN LOVE
BUT NOT WITH YOU!
YOU THINK THIS IS A GAME,
I'M TELLING YOU ITS NOT,
I THINK ABOUT HOW MUCH
OF A WHORE YOU ARE
WHILE I LAY ON MY COT.

AFTER 6 YEARS IN PRISON 1-4
FOR HOT URINE. THIS SUCKS.

4-10 YEARS FOR 8 CHECKS
TOTALING $700.00.

IF YOU ARE GOING THROUGH HELL,
KEEP GOING. -WISE

ARSON 5-10 SISTER SNITCHED.

JULY 3 FIRST DAY IN WESTERN.

8 TO 24 MONTHS FOR
3 DUI'S WITHIN 2 MONTHS!
PRO SE $1200 TOTAL FINES.

PRISON TERM 1-2 YEARS FOR A
ONE HITTER AND A GLASS PIPE,
PEACE, POT, MICRODOT. JESSIE
LOVES ME, STONED OR NOT.

YOU ARE AN IGNORAMUS.
GEORGE WASHINGTON CARVER
WOULD BE SO PROUD. HARRIET
TUBMAN WOULD TAKE YOU
BACK TO THE "MASSA" HERSELF
AND INSIST HE BEAT YOU.

HEAVEN'S BESIDE YOU
HELLS WITHIN YOU.

Melissa I **love** you too—I want to get with you. Mildred I **love** you, I want to make **love** to you. Real. Cheryl, I will come to see you when I get out. And Donna, I still **love** you too, and always will even if you did not know it, but I think you did.

STEVIE

This life in these walls is insanity! **Stop the madness now and live a healthy life.** What life brings and keeps a nigga down? Get a job, make a career, marry a girl, have some kids. **Live life!** What part will you continue to play?

DO YOU KNOW WHAT KIND OF BIRD DON'T FLY?
IF YOU DON'T KNOW THINK ABOUT IT. LAUGH WHEN YOU FIND OUT.
IT COULD BE — UNIQUE BIRD, A JAILBIRD, BIG BIRD.
HA—HA—HA.

I FEEL LIKE THIS. IF YOU ARE HERE FOR A P.V. DO WHAT YOU GOT
TO DO SO YOU CAN BE WITH YOUR **FAMILY.** IF YOU GOT TO DO LIFE,
WELL THAT'S FUCKED UP, BUT IF IT'S TRUE WHAT YOU DID TO GET
LIFE YOU SHOULD BE HERE. TO EVERYBODY ELSE DO YOUR TIME
AND GO HOME. STAY COOL. FUCK OFF!

THIS KITCHEN IS TEN TIMES BETTER THAN THE ACJ'S,
EVEN THE ECJ'S AND C.C.P. EBENSBURG.

WASH AND BRUSH YOUR TEETH OR GUMS WE DON'T WANT TO
SMELL YOUR SHITTY BREATH. DOG!!!

40—96 FOR BAD CHECKS, D.U.I., CREDIT CARD FRAUD, RECEIVING.
HANG DIS WHITE BOY.

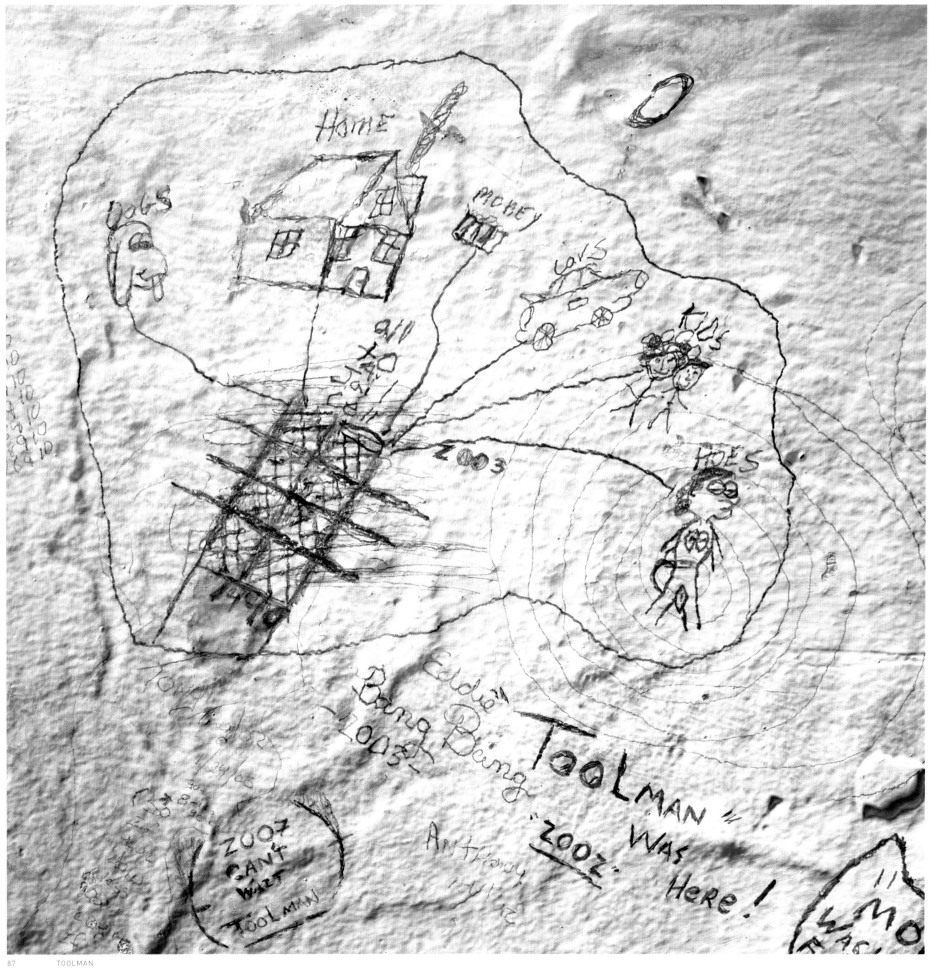

PAINT STORAGE ROOM, CORRECTIONAL INDUSTRIES

CRUTCHES AND CANE, PRISON HOSPITAL

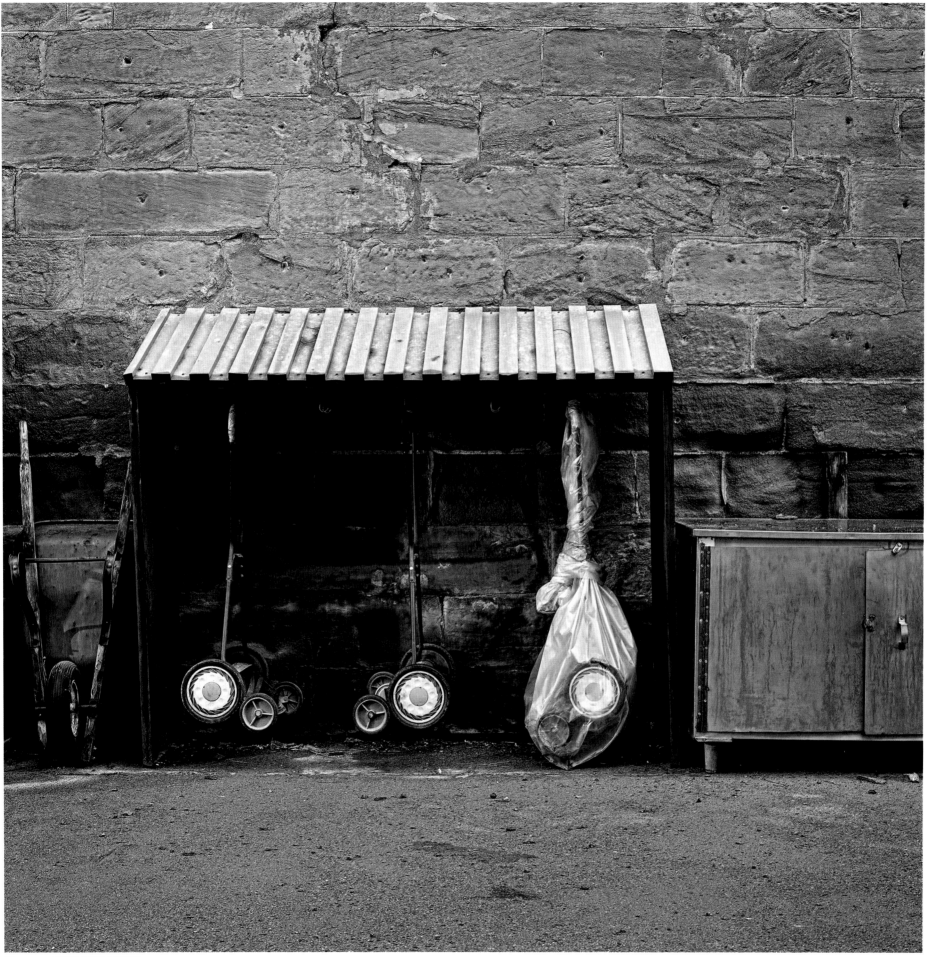

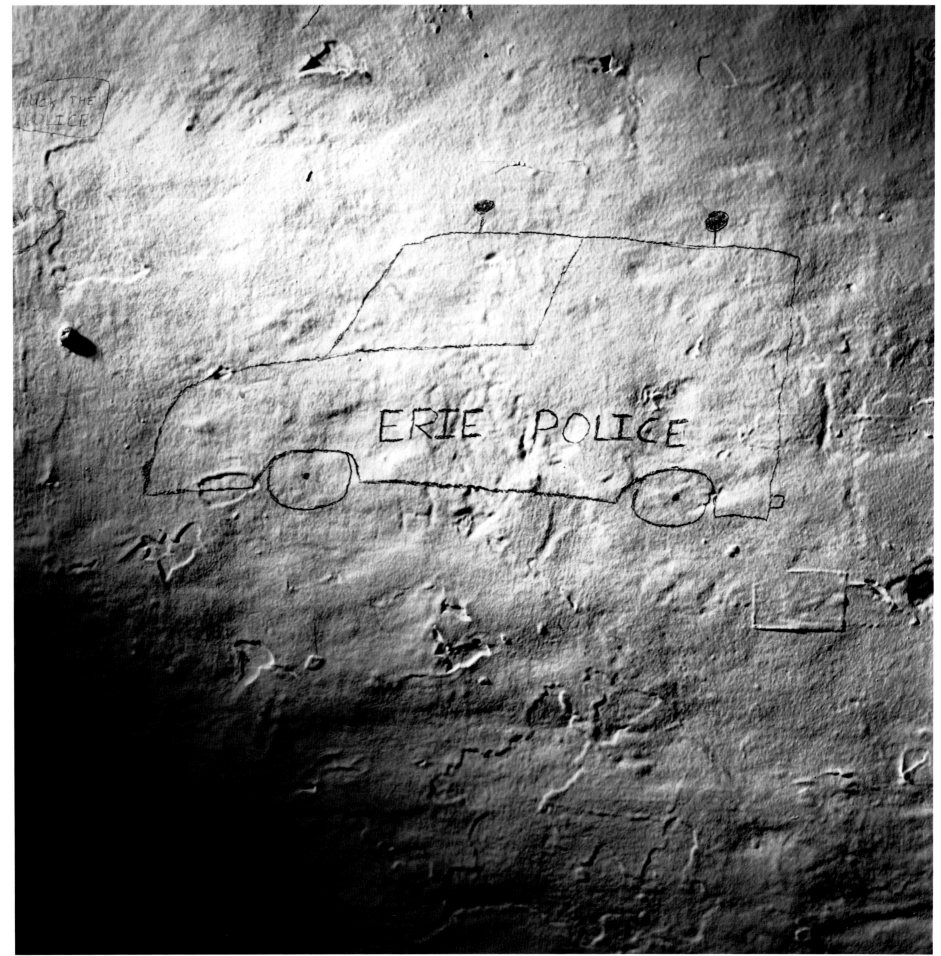

ERIE Get in where
you fit in, but if you don't
fit in, don't try to get in,
keeps this in mind.
It will help you get thru
this system. Peace.

ERIE 02

Just a little something
to help you on your way!

Eighteen first seen the
game.

Nineteen was the same.

Twenty took my ball.

Twenty one got ratted on
so I stand tall.

Twenty two took another
ride for a snitch.

Twenty three took the
blame for the dame
now she's gone and
I've got nothing but same.

Man I wish I would have
took the train, but when
I get out it won't be the
same 'cause it's fuck
everybody and if you were
me you'd do the same.

Barron—long black hair
sex abuse on his own kid
—see him at Camp Hill.

12 - 4 - 03

Prison contains more
talents than society,
we as convicts decide
not to use them.

THINK BEFORE YOU SPEAK. STICK TO YOUR KIND.
DON'T BORROW SHIT. DRINK PLENTY OF WATER. LEARN FROM YOUR MISTAKES,
BUT DON'T DWELL ON IT. LAST BUT NOT LEAST, DON'T DROP THE SOAP.
PROTECT YOUR ASS AT ALL COSTS, H.I.V. IS LIFE OR DEATH.

ARMSTRONG COUNTY, 10 MO. TECH HIT AND REVOCATION FOR NEW CHARGE.
PUNK ASS 3 MO. TO 24 MO. STATE. ENDED UP IN THE SAME CELL.

REMEMBER, THE ONLY JOB YOU START AT THE TOP IS DIGGIN A HOLE.

FOR PROTECTING SOME BITCH THAT I THOUGHT CARED ABOUT ME. **DIDN'T.**
GOT 4 TO 10 YEARS FOR SOMETHING I DIDN'T DO. DON'T EVER PROTECT ANY BITCH.
ASSAULT CHARGE. THEY TOOK MY CHILDREN AWAY FROM ME BECAUSE I LOVED HER.
DIDN'T WANT HER TO GO TO JAIL FOR ENDANGERING CHARGES,
SO THEY PUT ME IN JAIL.

I WAS GONE IN 60 SECONDS AND WAS CAUGHT 1 MONTH LATER BY SNITCHES.
(HAPPENS EVERY TIME!)

I'VE BEEN IN THE CRAWFORD COUNTY JAIL,
ERIE COUNTY JAIL,
VENANGO COUNTY JAIL,
SCI CAMP HILL ALSO,
SCI FRACVILLE,
OH YEAH, ARMSTRONG COUNTY JAIL (I THINK I'M DONE DOING TIME AFTER THIS ROUND).

EVERY ACT IS FRUITLESS UNLESS AN ACT CONTAINS COMPASSION (AND/OR) LOVE.

SOMETIMES YOU GOTTA KNOW THE END OF THINGS BEFORE YOU CAN UNDERSTAND THE **BEGINNING.**

LIFE IS BUT A DREAM. IT IS ONE VERSION OF WHAT REALLY EXISTS.

SELLIN DRUGS IS A BAD BIZ. YOUR OWN BROTHER WILL TAKE THE STAND ON YOU,
RATHER THAN HIM DO THE TIME. DON'T TRUST NO ONE!!
IT ALL COMES TO AN **END...**

ASIAN TONY FROM WEST END **IS A RAT.**
CRAIG IS ALWAYS LISTENING.

READ THE BIBLE DAILY.

MY RELEASE DATE 4-7-27

IF I TOLD YOU MY NAME YOU'D PROBABLY SAY
DAMN HE WAS HERE, SO JUST CALL ME YOUNG.
20 TO 40. HILLTOP. YET HERE.

I'VE BEEN BACK MOTHER SIX TIMES IN TWENTY
FIVE YEARS. I HAVE MADE AN ASS OF MYSELF
FOR THE LAST TIME. NO-MORE-EVER.

3-24-03

JAIL HOUSE FACT:
BELIEVE NO ONE,
TRUST NO ONE,
COUNT ON NOTH-
IN', OR NO ONE.
IT WILL HAPPEN
WEDNESDAY.

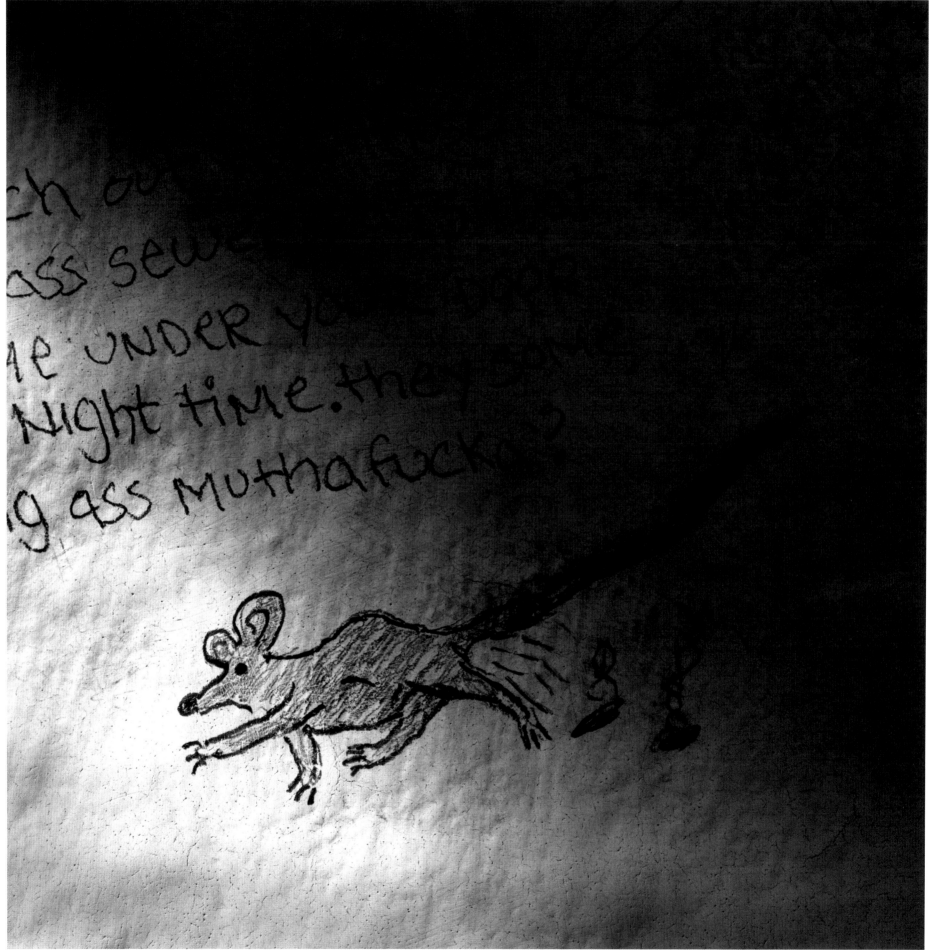

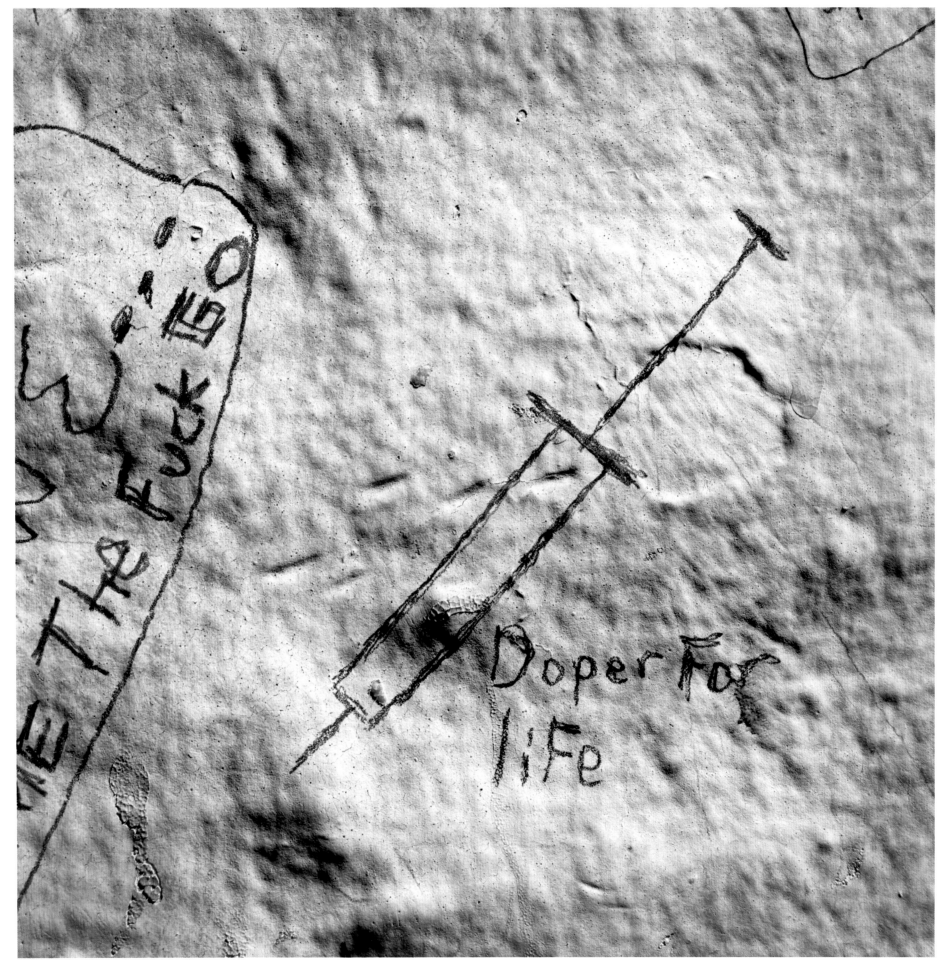

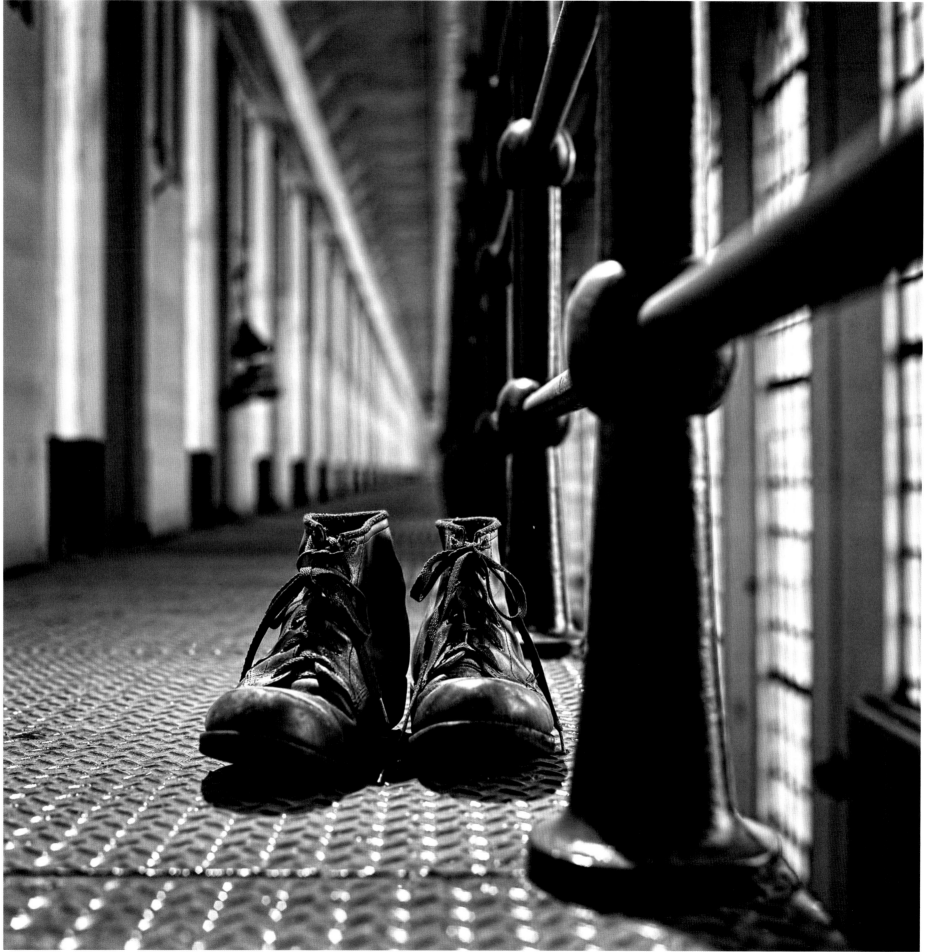

136

CELL

135

CELL

A THUG CHANGES.
LOVE CHANGES.
AND BEST FRIENDS
BECOME STRANGERS.
#4 REAL.
STAY SUCKER.

PLEASE DON'T
WASTE YOUR LIFE
AS I HAVE WASTED
MINE. SINCERELY,
ASK GOD FOR HIS
HELP. ASK FOR
THE WILLINGNESS
TO CHANGE.
DON'T HURT YOUR
FAMILY ANY MORE.

JUST STOP!!

STOP.

GOOD LUCK.
NEW YORK WAS HERE. 11-11-03

1979–1982 STRETCH.
BACK AFTER 21 YEARS ('03).

I BET CHARLIE MANSON NEVER HAD A
CELL THIS NASTY.

I PISSED ALL OVER THIS BED.

DOG, YOU CAN'T BEEF WITHOUT MONEY,
SO GET MONEY, THEN COME. HOLLA.!
GET MONEY.

JESUS WILL SAVE YOU, JUST ASK HIM TO.

THIS TOO SHALL PASS.

I AIN'T NO GANGSTA OR NAZI.
I JUST GOT A 1–2 FOR DUI. HA. HA.

1 ERIE

PENNSYLVANIA DON'T FUCK AROUND.
OHIO FUCKS AROUND.

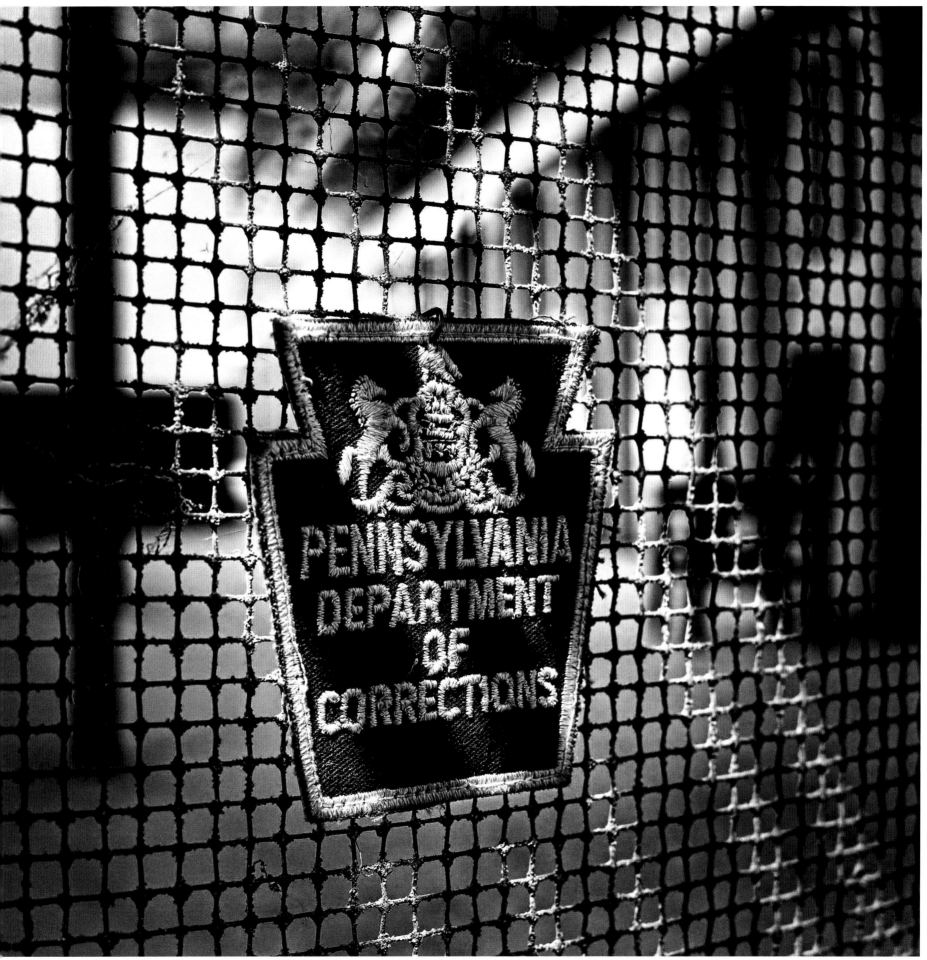

ACKNOWLEDGMENTS

I've never been in jail, never even been arrested. My first chance encounter with Western Penitentiary came in 1955, when I was nine years old. My parents had taken me to Pittsburgh, likely to shop for "school clothes" downtown at Kaufmann's, or to visit Oakland's Carnegie Museum, maybe both. As we headed home, after dark, we wound through Pittsburgh's Manchester neighborhood, then on to California Avenue, which quickly merged with Route 65. Without any warning, our car was stopped by a police roadblock as we approached the McKees Rocks Bridge. Prisoners had escaped. I remember hearing muffled voices, catching a glimpse of uniforms out my side window, and then the splash of a flashlight darting around the backseat with me. All the while, Western Penitentiary remained out of sight, just past the guardrail, and down at the bottom of the long, steep embankment.

Fifty years later, in 2005, I read about Western Penitentiary's imminent closing. That same day I wrote to the Pennsylvania Department of Corrections, asking for permission to photograph inside and outside the walls. I thank them for the opportunity they gave me to explore this briefly mothballed correctional institution.

Thanks to Bill Stickman, who walked me through Western Penitentiary's cellblocks, structures, and basement catacombs that first day. As well, thank you to every Corrections Officer for sharing your stories of the harrowing, and often terrifying, day-to-day life inside Western's walls.

I thank each prisoner who left the words and drawings for each other, and for us, that are presented here.

Thanks to Landesberg Design's Joe Petrina for his vision of *E Block*. Joe's powerful and nuanced combination of E Block's words and the photographs of Western Penitentiary's spaces of confinement is brilliant. It's an unflinching presentation of the sometimes bitter and full of rage, sometimes difficult and incomprehensible, sometimes remorseful and sometimes humorous words and drawings made by prisoners in their first days of incarceration.

His gutsy treatment of these words gives them the same stark and terrifying power I felt when I first read them standing alone in those empty silent prison cells. Thank you, Joe, for this gift to all of us. Thanks to Anita Driscoll for helping distill the words and pictures I gathered at the Penitentiary site.

Thanks to the Pennsylvania Historical and Museum Commission for permission to share excerpts from *Two Centuries of Corrections in Pennsylvania*.

My thanks to author Adam Gopnik, and to Condé Nast, for permission to reprint "The Caging of America," first published in the January 30, 2012, issue of *The New Yorker*. Gopnik's words gave me a place to stand, at some small distance, and look again at Western Penitentiary and the staggering statistics of incarceration in America. I want to believe Gopnik's conclusion that "many small acts are possible that will help end the epidemic of imprisonment." *E Block* is my small act.

My heartfelt appreciation to William DiMascio for a chance to bring the Western Penitentiary words and pictures to his North Broad Street office, one warm morning in July, a few years back. Thank you for your early interest in this project.

I thank Ivan C. Karp (1926–2012) for organizing the first exhibition of these photographs at the OK Harris Gallery in 2010. In many ways his insights and astute observations are reflected in the selection of images presented here.

I am grateful to Pittsburgh Center for the Arts, and especially Laura Domencic, Jasdeep Khaira, and Charlie Humphrey, for their enthusiastic support for *E Block*. They were a constant source of advice and encouragement during the roller-coaster ride of organizing this project. Each of their generous contributions sustained this work in different ways. Beyond that, the Center's Artist's Services support was an essential and critical component of the successful outcome of *E Block*. I am so very grateful.

I thank you Phillip Hallen, for your thoughts and insight, one more gift of countless others lifelong. Special thanks, as well, to the many individuals who contributed as this project moved along, including Louise Sturgess, who wrote many times in support of this work, and others who shared without hesitation, including Rick Landesberg, David Bergholz, Christian Ehret, and Michael Simms.

In some mostly unknown ways, this project began in 1962, when I first picked up a camera. Thanks to William Moos (1919–1984), a gentle and benevolent teacher who directed my first attempts at making photographs. Thanks to Richard Kleeman (1928–2001), painter, photographer, teacher, mentor, and good friend, who wrote with insight and kindness, from time to time, in response to seeing some of my photographs.

Without the support of Pittsburgh's foundation community, this book would not have been possible. I am grateful for the generosity of the following foundations: The Heinz Endowments, the Falk Foundation, the McCune Foundation, the Falk Family Fund, The Fine Foundation, and The Pittsburgh Foundation. Often, during presentations of this work in progress, their careful questions helped refine the E Block project, and this book.

Thank you, Joan, for listening.

MARK PERROTT